So You Think You Know Gettysburg?

**Also by James Gindlesperger**

*Escape from Libby Prison*
*Fire on the Water*

# So You Think You Know Gettysburg?

The Stories Behind the Monuments and the Men
Who Fought One of America's Most Epic Battles

## James and Suzanne Gindlesperger

JOHN F. BLAIR
PUBLISHER
*Winston-Salem, North Carolina*

JOHN F. BLAIR
P U B L I S H E R
1406 Plaza Drive
Winston-Salem, North Carolina 27103
www.blairpub.com

Manufactured in South Korea

COVER IMAGES

*Front cover - The Confederate batteries on West Confederate Avenue / Seminary Ridge*
*Back cover left to right - Louisiana State Memorial, Irish Brigade Monument, General George Gordon Meade Monument,*
*Ninety-ninth Pennsylvania Infantry Monument, and Brigadier General Samuel Wylie Crawford Monument*

Library of Congress Cataloging-in-Publication Data

Gindlesperger, James, 1941-
  So you think you know Gettysburg? : the stories behind the monuments and the men who fought one of America's most epic battles / by James and Suzanne Gindlesperger.
    p. cm.
  Includes index.
  ISBN 978-0-89587-374-3
  1. Gettysburg National Military Park (Pa.)—Tours. 2. Gettysburg, Battle of, Gettysburg, Pa., 1863. 3. United States—History—Civil War, 1861-1865—Monuments. I. Gindlesperger, Suzanne. II. Title.
  E475.56.G744 2010
  973.7'349—dc22
                    2009045842

www.blairpub.com
DESIGN BY DEBRA LONG HAMPTON

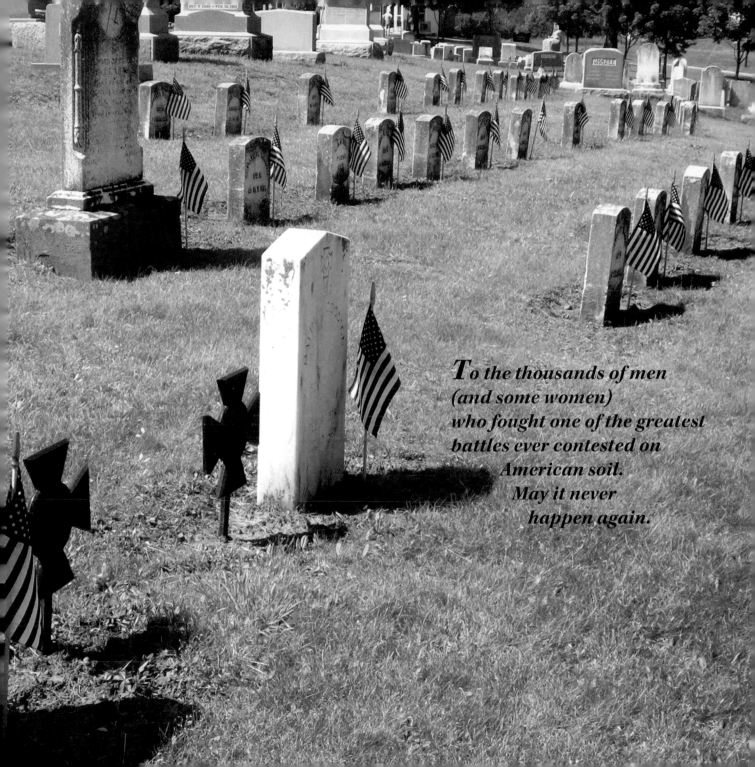

*T*o the thousands of men
(and some women)
who fought one of the greatest
battles ever contested on
American soil.
May it never
happen again.

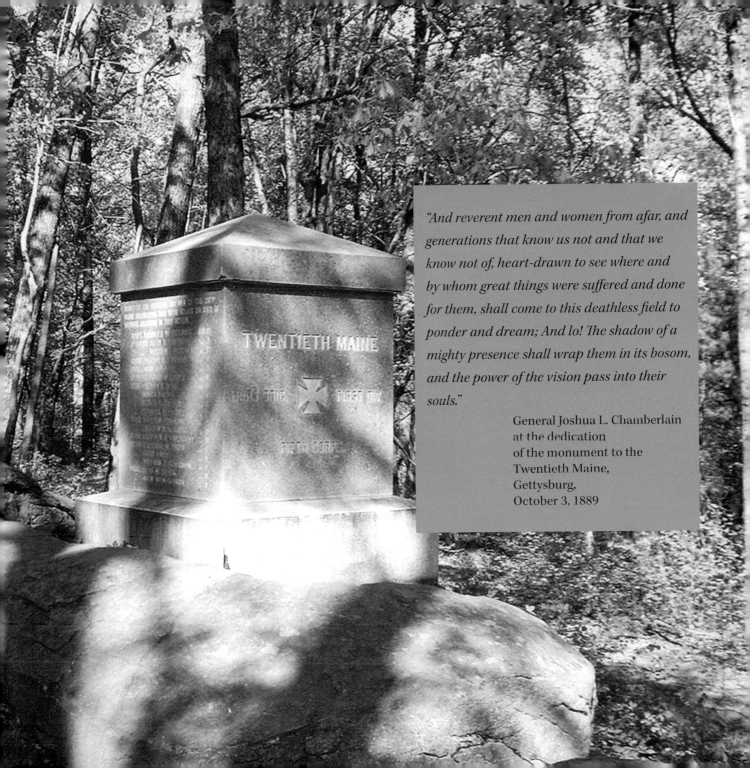

"*And reverent men and women from afar, and generations that know us not and that we know not of, heart-drawn to see where and by whom great things were suffered and done for them, shall come to this deathless field to ponder and dream; And lo! The shadow of a mighty presence shall wrap them in its bosom, and the power of the vision pass into their souls.*"

General Joshua L. Chamberlain
at the dedication
of the monument to the
Twentieth Maine,
Gettysburg,
October 3, 1889

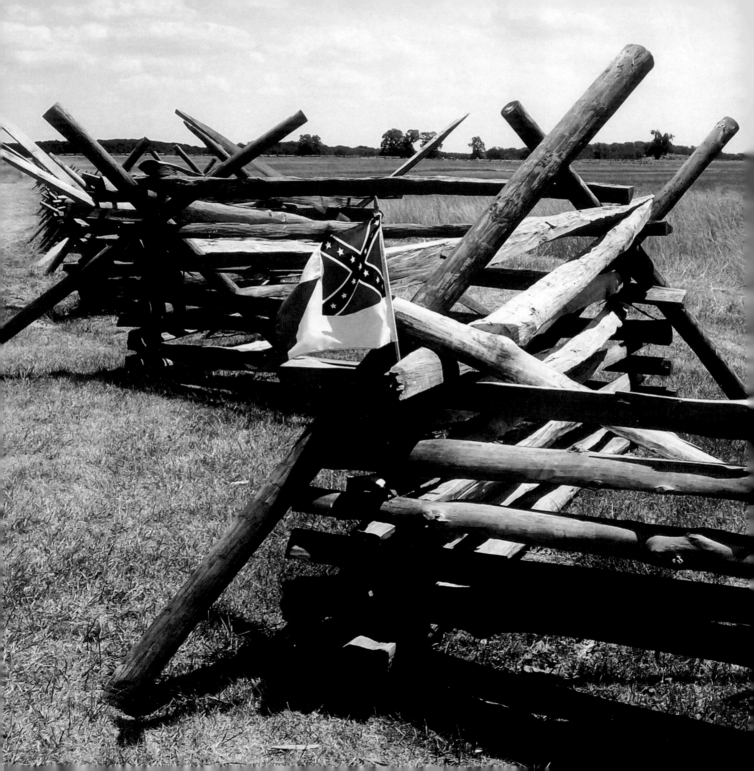

# Contents

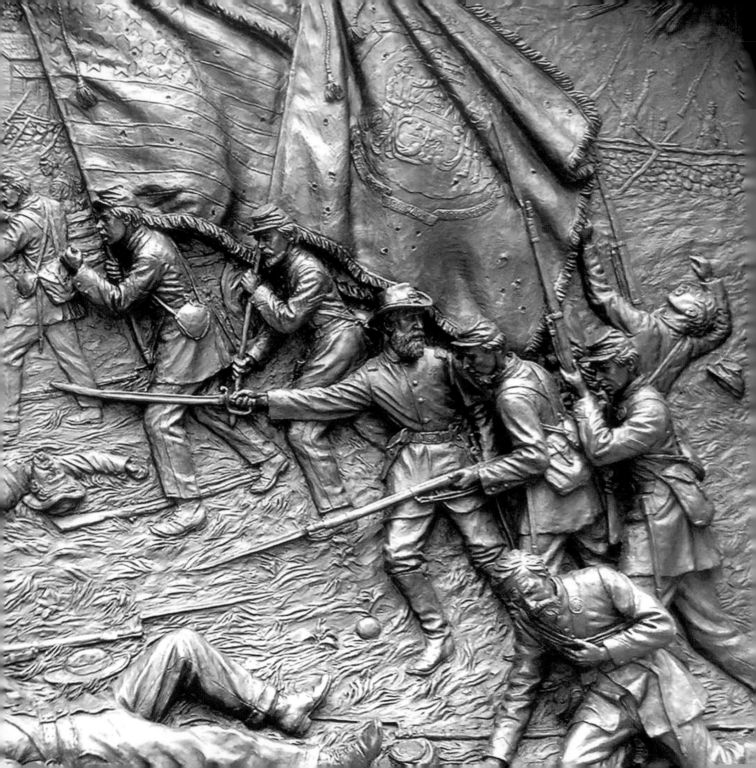

## Chapter 4
### Area D—Culp's Hill 63

## Chapter 5
### Area E—West Confederate Avenue, North End 75

## Chapter 6
### Area F—West Confederate Avenue, South End 87

## Chapter 9
### Area I—Little Round Top, Devil's Den 145

## Chapter 10
### Area J—East Cavalry Battlefield 165

## Chapter 11
### General 175

# Gettysburg Battlefield   July 1 – 3, 1863

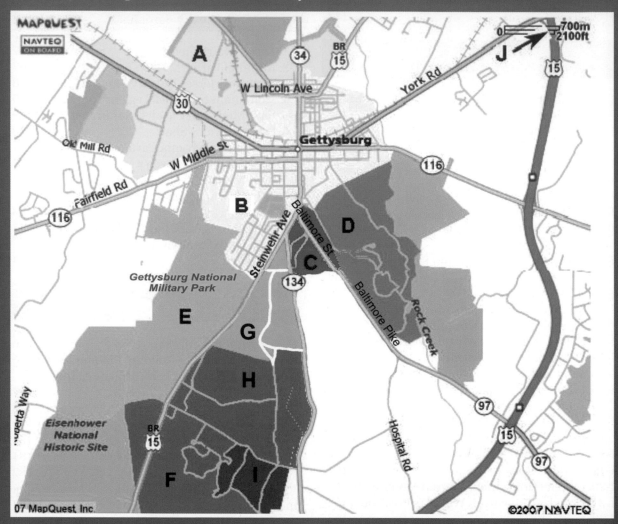

# Preface

Few events in our nation's history hold as much fascination as the Civil War. Military officers study it for its tactics and strategies, while schoolchildren study it to learn about history. Genealogists study it to learn where and how their ancestors fought, and perhaps died, either to preserve the Union or to defend states' rights, up to and including the right of secession. Whatever the reason, the fascination with the four years from 1861 to 1865 continues to grow.

Within that war, few battles grip us more than Gettysburg, the so-called high-water mark of the Confederacy. Statistics show that Gettysburg is the most popular Civil War site in the National Park Service system, drawing some 1.7 million visitors annually.

The authors have contributed more than most to that statistic. We have had a decades-long love affair with Gettysburg and rarely go longer than a few months without a pilgrimage to that hallowed ground. We have reached the point where friends and relatives roll their eyes when we announce we will be gone for a few days, knowing the odds are good that we are going to Gettysburg yet again.

Each visit finds us taking photographs, often of things we have shot countless times before. The wonders of digital photography have allowed us to delete the inferior shots, keeping only those that capture elusive lighting effects and shadows, those that offer more scenic panoramas than previous versions, and those we just plain like for no particular reason.

In this book, the photos and their accompanying descriptions are grouped according to areas of the battlefield. The color-coded map of the entire battlefield allows readers to select specific portions of the field, using the areas' colors and letter designations as guides. The photos in turn have numbers corresponding to those on

the accompanying area maps. Readers can use those numbers to determine where the photos were taken, which will allow them to read the explanations that accompany the photos while contemplating what took place on those very spots more than 145 years ago. We have also included GPS coordinates for those who prefer to test their navigational skills.

One short chapter is devoted to general-interest photos. These show features that appear in all areas of the battlefield and are not exclusive to any one section. Examples of such photos are those of flank markers, brigade plaques, and reenactment scenes. Because they do not appear on specific maps, they have been given general numbers. Their descriptive narratives serve to make a visit to the battlefield more meaningful.

We have made no attempt to present the entire history of the battle, although much can be learned simply by reading the narratives accompanying the photographs. We also have not depicted every monument on the field, although we have tried to balance the story by presenting photos for each side of the battle line. We do not editorialize as to which side was right and which was wrong, or which side showed more courage. That is left to readers, should they desire to make such judgments.

Some of the photos and narratives will reveal trivia readers never knew. Others share the heartbreak of war. Still others simply explain the beauty of a scene that belies the cacophony and unbelievably savage fighting that occurred on the pieces of ground depicted.

The pages that follow present a collection of photos and the interesting stories behind them. These are our favorites. We hope you like them.

# Acknowledgments

The people who staff the visitor center at the Gettysburg National Military Park were very helpful, and we thank them for all they have done for us. We especially appreciate the guides, with whom we had many discussions and from whom we learned much.

We must also acknowledge the nice people at the Lutheran Theological Seminary's Schmucker Hall for their hospitality and generosity in allowing us to climb into the famed cupola. The feeling of awe in standing where famous generals plotted their strategies was powerful, and we thank them for the opportunity.

Thanks also to Amanda Smith and the MapQuest permission team for allowing us to use their maps. Their generosity saved us countless hours of cartographic work, and the results are far beyond anything we would have come up with on our own.

Our agent, Rita Rosenkranz, has been more than her title implies. She gave us sage advice, offered critical suggestions, and served as our mentor. Perhaps even more, she has become our friend. Thank you, Rita.

We also appreciate the generosity of the staff at the National Archives for making available the 1863 photo of the Confederate sharpshooter in Devil's Den (photos I-6). That period photograph allowed us to compare our modern photo with the way things looked at the time of the battle, making the written discussion much more meaningful.

Our employers, AAA of Southern Pennsylvania and Carnegie Mellon University, must be recognized for their support and flexibility in enabling us to get to Gettysburg so often. Those folks were great!

Finally, we thank our friends and relatives for their continuing encouragement. While they may not have always understood the magnetism of Gettysburg, they never failed to support our efforts. We value their presence in our lives and can never thank them enough.

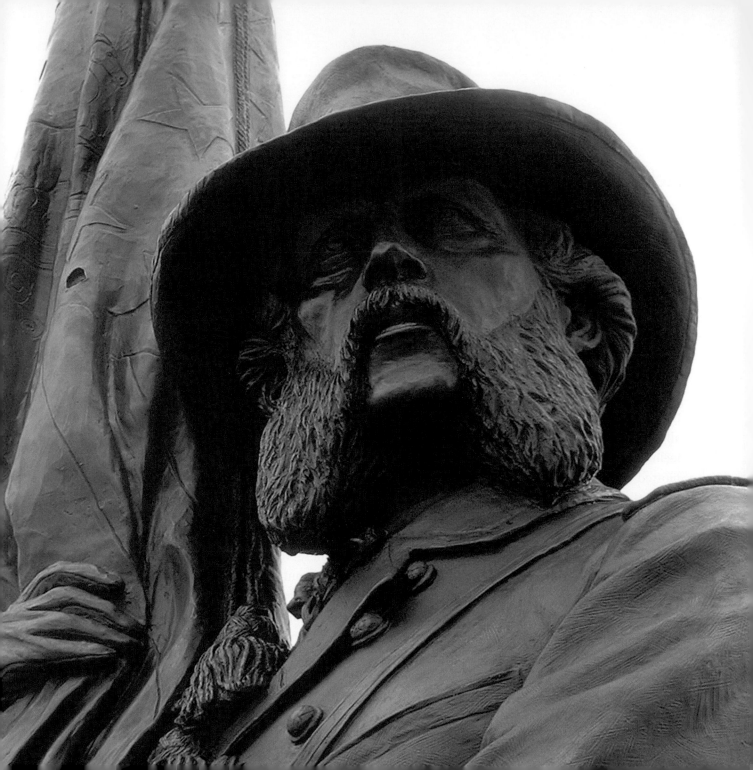

# Introduction

By July 1863, the Civil War was entering its third year. Both sides had suffered greatly, neither having expected the conflict to last more than a few months. Both had badly miscalculated.

The Army of Northern Virginia had recently registered a major victory at Chancellorsville. The confidence of the Confederate army under Robert E. Lee had never been higher. Although they were outmanned, the Confederates had General Lee, and that had proven to be the difference so far.

Flush with his victory at Chancellorsville, Lee chose to take advantage of the demoralized Union army by invading the North. His aim was to move the war away from Virginia, taking the Union forces with him. He also hoped to force the Union to move troops away from Vicksburg, Mississippi, where a siege was strangling what had been a Confederate stronghold.

Lee reasoned that a victory on Northern soil would have a significant impact on the political efforts to gain a compromise that would end the war and allow the seceded states to form their own confederacy. President Abraham Lincoln was under pressure to resolve the conflict, and Lee hoped to speed the process by defeating his foe in his own backyard.

Major General Joseph Hooker, who had squandered his opportunity at Chancellorsville, now found himself out of favor with the Union's War Department and, perhaps more importantly, with Lincoln. The commander of the Army of the Potomac had chosen to fight a defensive battle at Chancellorsville despite having an advantage in both manpower and position. The devastating results had many in Washington doubting Hooker's ability.

In mid-June, Lee's troops moved into Maryland and Pennsylvania. Hooker was slow to follow. As the Confederates threatened Harrisburg and York, Northern politicians demanded something be done to bring their advance to a halt. The embattled Hooker, frustrated by what he perceived as a lack of support from Washington, finally offered his resignation on June 28. It was promptly accepted, and Major General George Gordon Meade reluctantly became his successor after Major General John Reynolds refused the appointment. Meade's famous quote, "I have been tried and condemned," reflected his lack of enthusiasm for the job.

Meade sent his army northward out of Frederick, Maryland, hoping to entice Lee into a confrontation. That confrontation came at Gettysburg in a three-day battle that changed the course of history.

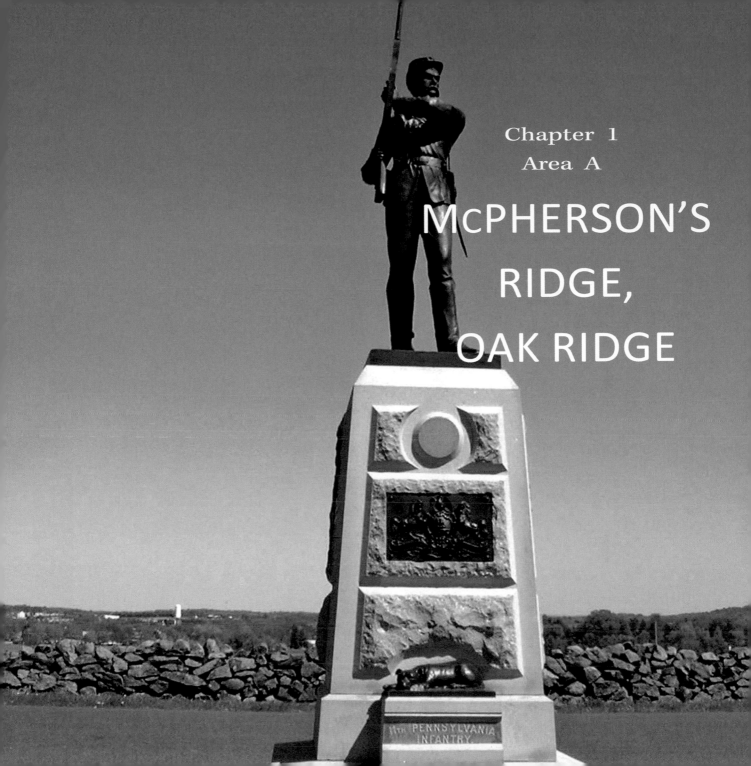

Chapter 1
Area A

# McPHERSON'S RIDGE, OAK RIDGE

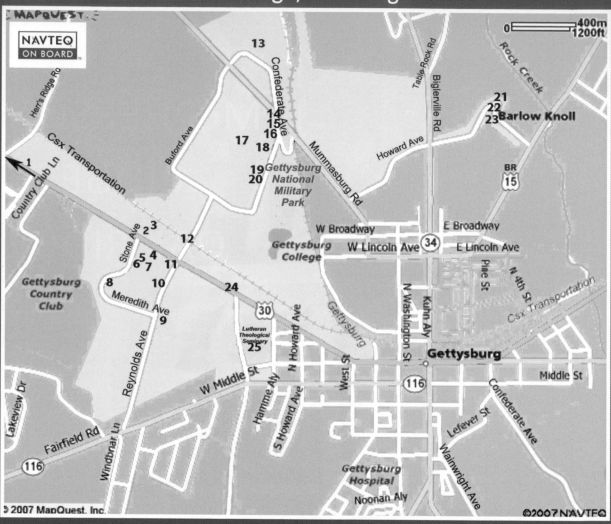

## A-1: First Shot Monuments
**39º51.058'N, 77º16.844'W (left) and 39º50.277'N, 77º15.099'W (right)**

Many people are understandably confused when they see two separate markers claiming to represent the first shot of the battle. That confusion is amplified when one considers that they are not even close to each other. The explanation, although relatively simple, is not without controversy.

The photo on the right shows a plate affixed to a three-inch rifle, one of four such weapons adorning the base of the monument to General John Buford (see photo on the left on page 5).

The plate states that the gun belonged to Horse Battery A of the Second United States Artillery, and that it was the opening gun of the battle. The shot was fired under the direction of Buford.

The photo on the left, however, shows what is commonly referred to as "the First Shot Monument," placed by the man who claimed to have fired that shot, Lieutenant Marcellus E. Jones of the Eighth Illinois Cavalry.

How can both claims be true?

The answer lies in a technicality. The shot fired under Buford's command was the opening artillery round and may have started the actual fighting. But the real first shot was fired earlier in the morning by pickets. Whether or not it was fired by Jones, however, is open to conjecture.

At about seven-thirty in the morning on July 1, 1863, pickets from the Eighth Illinois Cavalry were positioned along the Chambersburg Pike

with pickets from the Twelfth Illinois and the Third Indiana. Jones saw a cloud of dust in the direction of Cashtown, indicating the approach of Major General Henry Heth's Confederate division. The Union pickets watched intently as the Confederate troops came into view near Marsh Creek. Jones, who was commanding the Eighth Illinois pickets, borrowed a carbine from Sergeant Levi Shaffer and squeezed off a shot at an officer. Although the distance was too great for the round to have any effect, this was claimed to be the first shot of the battle.

Confederate artillery under the command of Major William R. J. Pegram returned fire, the first round hitting the trees above the heads of the Union pickets. This drew the attention of the farm's owner, Ephraim Wisler, who came out of his house to observe the action. Pegram's second shot was lower, striking dangerously near Wisler, who quickly retreated into his home. Badly shaken by his close encounter, Wisler died a short time later of heart failure.

The First Shot Monument is not on the actual battlefield, nor is it an official monument. Jones, Shaffer, and a third man, Alex Riddler, brought the limestone shrine from Naperville, Illinois, in 1883. Jones had purchased a small plot of ground from James Mickler, the new owner of the Ephraim Wisler farm, to mark the location where he had stood when he fired his shot, and this was to be the home of the monument he had

purchased. Half the shaft is buried in the ground to provide stability. It should be pointed out that the Chambersburg Pike was level with the yard at the time of the battle but was lowered years later when the surface was macadamized.

First-shot claims were also made by the Thirteenth Alabama Regiment, the Fifth Alabama Battalion, the Seventeenth Pennsylvania Cavalry, the Sixth New York Cavalry, and the Ninth New York Cavalry, so Jones's claim may or may not be true. It is unlikely the answer will ever be known with any degree of certainty.

Some evidence also exists that the artillery shot from Buford's men was actually in answer to a shell fired by Marye's Fredericksburg Battery, so the plaque mounted on the Second United States Artillery's gun may also be in error.

## A-2: John Buford Monument
### 39º50.277'N, 77º15.099'W

To Brigadier General John Buford fell the responsibility of putting up the initial defense against Major General Henry Heth's advancing Confederate army on the morning of July 1, 1863. His three thousand cavalrymen soon found themselves in the midst of the heaviest fighting they had seen. Under Buford's command, the outmanned Federals were able to hold off Heth's

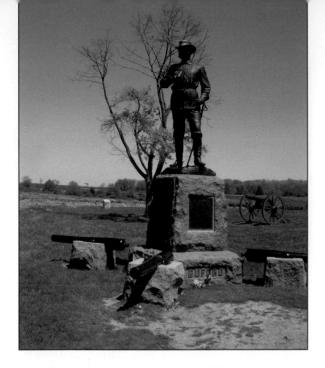

## A-3: John Reynolds Monument
**39º50.272'N, 77º15.078'W**

One of three monuments to Major General John Reynolds on the battlefield (see photos A-10 and C-5), this engineering marvel shows Reynolds on his horse. The statue weighs in excess of nine thousand pounds yet is balanced and supported by only two hoofs. Dedicated in 1899, it has stood in this position for more than a century without reinforcement.

Reynolds commanded the First Corps when he arrived on the field the morning of July 1, 1863. Although he was killed early in the fighting, his actions were credited with providing the Union army valuable time. Some question exists as to whether Reynolds was killed by an enemy sniper or a stray bullet, but it mattered little. Either way,

men long enough to buy valuable time for the Union army.

In what would become a famous exchange, Buford was asked by Major General John Reynolds on Reynolds's arrival on the field, "What goes, John?" To which Buford is said to have replied, "The Devil's to pay!"

Following the twenty-fifth anniversary of the battle, the Buford Memorial Association was formed with the task of designing and erecting a monument to Buford. The photo above depicts the result of that work. Surrounding the base of the monument are four ordnance rifles, one of which is number 233, the gun credited with firing the first artillery round of the battle (see photo A-1, right).

the Union army lost one of its most promising officers.

## A-4: McPherson Farm
**39º50.223'N, 77º15.079'W**

Brigadier General John Buford's Union cavalry division occupied the ground around the Edward McPherson farm on the morning of July 1. At that time, the property was being farmed by John Slentz while McPherson was serving in Washington as chief clerk of the House of Representatives. Many of the wounded from both sides were treated in the original barn that stood on this site. The farm sustained significant damage during the battle. McPherson sold it in 1868, and the National Park Service purchased the property in 1904. The barn, in poor condition, was the only surviving building by then. It has since been restored to its present appearance.

Fighting in this area was especially bloody, the two sides firing at each other at point-blank range. One participant stated that the two lines could not have been more than twenty paces apart. Among the wounded was General Henry Heth, knocked senseless when he was struck in the head by a Union bullet. Fortunately, Heth was wearing a new hat into which he had inserted rolled-up newspaper to improve the fit. The bullet's path was diverted by the newspaper, which sent it around the perimeter of his head, causing a scalp wound. Dazed, Heth was helped from the field. He was replaced by Brigadier General James J. Pettigrew.

## A-5: View from McPherson Ridge to Seminary Ridge
**39º50.156'N, 77º15.160'W**

The view above is what was seen by Heth's Confederate forces as they attacked the Union position on McPherson Ridge on the first day of fighting. Seminary Ridge appears in the background. The spire is that of the Lutheran Theological Seminary chapel. Fierce fighting took place in this area that day.

## A-6: John Burns Monument
**39º50.157'N, 77º15.164'W**

As the battle began to unfold, seventy-two-year-old John Burns, a veteran of the War of 1812, decided to enter the fray. Carrying an old flintlock musket, he walked from his Gettysburg home to McPherson Ridge and asked a Union officer where he could best be used. The surprised officer placed Burns with the Iron Brigade, with whom he fought for several hours despite being twice wounded. His third wound finally drove him from the field.

When word of his exploits got out after the battle, he became a national hero. President Lincoln asked to meet Burns when he came to Gettysburg to dedicate the national cemetery in November.

Years after the battle, a Pennsylvania chapter of the Sons of Union Veterans proposed that a monument to Burns be placed on the battlefield where he gained his fame. His monument depicts

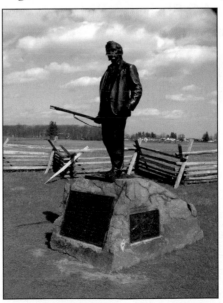

Burns carrying his flintlock musket, although in reality he used a rifled musket borrowed from a wounded soldier. The monument is located about where he fought with the 150th Pennsylvania and the Second Wisconsin regiments. He is shown standing on a boulder that was in the area at the time of the fighting.

After the war, Burns led a popular battlefield tour in the McPherson Ridge area. However, during one such tour, he thought he saw the ghost of a soldier he had seen killed in the fighting. Burns claimed that the soldier beckoned for him to follow. The experience left Burns so shaken that he never returned to the area.

edge of this small wood lot was the site of General John Reynolds's death, giving rise to an alternate name: Reynolds Woods.

## A-7: McPherson Ridge
**39º50.157'N, 77º15.164'W**

On the morning of July 1, 1863, General Henry Heth led a column of Confederate troops from Cashtown to Gettysburg, where he was met by Union pickets. Sporadic fighting ensued while the pickets waited for reinforcements in the form of Union infantry. Much of the early fighting took place along McPherson Ridge just south of the Chambersburg Pike (now U.S. 30). This bucolic scene is a far cry from the fierce fighting along the fence line on the morning of the battle's first day. The wooded area is Herbst Woods, named for its wartime owner, John Herbst. The eastern

## A-8: Iron Brigade Monument
**39º50.129'N, 77º15.255'W**

The Iron Brigade was made up of the Second, Sixth, and Seventh Wisconsin volunteer infantries and the Nineteenth Indiana. Later, to fill in for heavy losses, the Twenty-fourth Michigan was added. The original nickname, "the Black Hat Brigade," arose from the stiff, broad-brimmed, formal black hats first worn by only the Sixth Wisconsin. Brigadier General John Gibbon, the commander, liked the hats and ordered the other regiments of the brigade to also begin wearing them. They soon became a source of pride.

At South Mountain during the Antietam

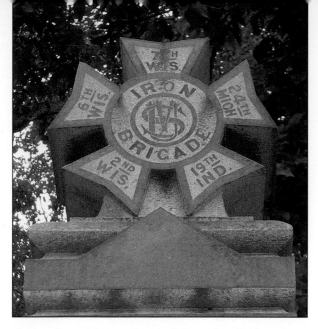

Campaign, Major General Joseph Hooker was so impressed with the brigade's fighting abilities and the way it resisted enemy fire that he said it must be made of iron. The reference stuck, and "the Iron Brigade" soon became the name by which it was best known.

At Gettysburg, the brigade was heavily occupied on the morning of the first day. Of the 1,883 men who entered battle, only 671 remained at the end of the day.

## A-9: Abner Doubleday Monument
**39º49.982'N, 77º15.045'W**

Doubleday is best known for his alleged founding of the game of baseball, which is actually not true. His next most famous deed was aiming and firing the first Union cannon shot at Fort Sumter in Charleston Harbor in 1861, the action that launched the Civil War. Less known but arguably more important was his performance at Gettysburg.

As the battle unfolded, Doubleday's division quickly reinforced Brigadier General John Buford's cavalry division. Upon the death of Major General John Reynolds, Doubleday took command of the Union's First Corps, leading fewer than ten thousand men against a Confederate force nearly twice as large. The Union troops fought desperately for several hours, at which time Doubleday recognized they could not hold the ground and ordered a withdrawal to Seminary Ridge. That withdrawal eventually deteriorated into a chaotic

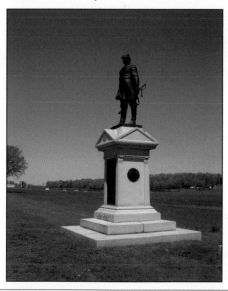

retreat, leading Major General Oliver O. Howard to charge that Doubleday had allowed the line to break. That charge led to Doubleday's removal from command of the corps the next day. Major General George G. Meade replaced him with Major General John Newton. In truth, however, Union forces under Doubleday had delayed the Confederate advance and contributed to the ultimate Union victory.

The humiliated Doubleday returned to division command, at which post he acquired a wound in the neck. When Meade refused his request for reinstatement as First Corps commander, Doubleday asked to be relieved of his command. Meade accepted the request, and Doubleday left the Union army only days after the Battle of Gettysburg was over.

The monument to Doubleday is located in the approximate center of the line held by his division, overlooking the area where his men fought bravely against overwhelming odds.

## A-10: Reynolds Shooting Site
**39º50.064'N, 77º15.058'W**

Major General John Reynolds, from nearby Lancaster, Pennsylvania, was offered command of the Union army just before Gettysburg but turned it down because he was unable to get a guarantee he would not face interference from

Washington. The command was then offered to General George Meade. As Reynolds, known as a hands-on commander, was directing the Iron Brigade in a countercharge against Archer's Brigade, he was struck behind the ear by a minie ball that killed him instantly. He had been on the field only an hour. He is honored not only by the marker above showing where he was killed but also by a nearby monument (see photo A-3) and another in the national cemetery (see photo C-5).

## A-11: 143rd Pennsylvania Infantry Monument
**39º50.195'N, 77º14.958'W**

The 143rd Pennsylvania Infantry arrived on the field around noon on the first day's fighting, during a lull in the battle. It was the 143rd's

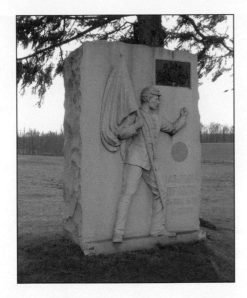

Samuel Pfiffer of Company I, who defiantly faced the approaching Confederates. The dispute has never been resolved. It is entirely possible that both color bearers did what was claimed.

## A-12: Railroad Cut
**39º50.264'N, 77º14.884'W**

As the battle raged around the McPherson Farm, a Union brigade under Brigadier General Lysander Cutler moved northward across the Chambersburg Pike, where it engaged Confederate troops under Brigadier General Joseph R. Davis. After the Southerners drove Cutler's men back, Davis turned his men toward the McPherson Farm to continue the attack. There, he encountered the Sixth Wisconsin, a reserve unit from the Iron Brigade. Under Lieutenant Colonel Rufus Dawes, the Sixth Wisconsin concentrated its

first taste of action in the war. As Lieutenant General A. P. Hill's Confederate troops drove the Union army back across the McPherson Farm toward Seminary Ridge, the Union regiment's color bearer periodically turned and shook his fist boldly at Hill's men. That courageous color bearer, Sergeant Benjamin Crippin, would not make it back with the rest of his company, as he was killed in his final act of defiance. His actions so impressed his comrades that they honored him on their monument, where he is depicted as they last saw him, shaking his fist at the enemy. Crippin's body was never identified. He probably lies in the national cemetery as one of the many "unknowns."

The men of the 150th Pennsylvania later claimed it was their color bearer, Sergeant

fire on the oncoming enemy, eventually forcing the Confederates back toward this railroad bed, which was excavated but not yet completed at the time of the battle. Joined by the Ninety-fifth New York Infantry and the Fourteenth Brooklyn, the men charged across four hundred yards of open field toward the railroad bed, filled with soldiers from the Second and Forty-second Mississippi and the Fifty-fifth North Carolina. As can be appreciated from the photo on page 11, the high walls of the cut prevented the Southerners from escaping. Only their surrender saved them from total annihilation. Some 225 Confederate troops, most from the Second Mississippi, were taken prisoner.

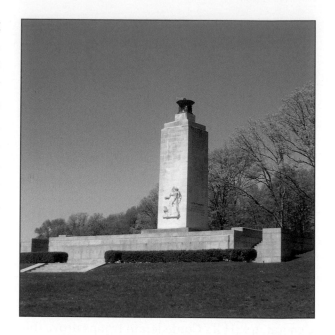

## A-13: Eternal Light Peace Memorial
**39º50.907'N, 77º14.608'W**

Veterans of both armies proposed the monument above at the fiftieth anniversary and reunion of the battle to illustrate the unification of the country and the hope for eternal peace. Despite the noble purpose, however, it took twenty-five years to raise the sixty thousand dollars to build the monument. The memorial is truly a symbol of peace and reconciliation. Its base is constructed of Maine granite and its shaft of Alabama limestone.

On July 3, 1938, at the battle's seventy-fifth anniversary reunion, a former Union soldier joined a former Confederate in pulling a cord to unveil the monument, much to the joy of the eighteen hundred veterans in attendance. President Franklin Delano Roosevelt, following his speech to a crowd of a quarter-million people, then ignited a flame at the top of the monument.

The monument, referred to by some simply as "the Peace Light," is one of the most visited sites on the battlefield. Except for a period during the 1970s and 1980s when the flame was replaced by an electric light because of the shortage of natural gas, it has burned continuously.

## A-14: Ninetieth Pennsylvania Infantry Monument
**39º50.660'N, 77º14.519'W**

One monument that draws a great deal of interest on the Gettysburg battlefield is that of the Ninetieth Pennsylvania Infantry. The reason? Its unusual design. Carved in the form of a tree defoliated by the battle, it contains the usual tools of war. A knapsack hangs over a broken branch, along with a musket and canteen. Ivy climbs the trunk of the damaged tree. And on the stub of a top branch rests a bird's nest, where babies are watched over by their mother. It is this bird's nest that makes the monument unique.

Legend has it that the monument was meant to depict an act of kindness in the heat of the battle, although the story has never been documented. As the story goes, an artillery shell struck a tree near the Ninetieth Pennsylvania, knocking a robin's nest out of the branches. The nest, complete with a new brood of baby robins, remained intact. A soldier from the Ninetieth Pennsylvania is said to have picked up the nest and gently replaced it in the tree while under heavy fire. Did it really happen? Nobody can say with certainty, but the story lives forever in the form of this monument.

## A-15: Twelfth Massachusetts Infantry Monument
**39º50.622'N, 77º14.524'W**

Nicknamed "the Webster Regiment," the Twelfth Massachusetts is honored by this

This monument was erected in 1885, making it one of the earliest on the field.

## A-16: Eighty-eighth Pennsylvania Infantry Monument
**39º50.603'N, 77º14.526'W**

Comprised mostly of Pennsylvania Dutch recruits, the Eighty-eighth Pennsylvania was one of the regiments that decimated General Alfred Iverson's brigade (see photo A-17). During the

monument, a large minie bullet wrapped in an American flag. A likeness of Daniel Webster adorns the front. Webster's son Fletcher had been the regiment's commander until his death in 1862. A quote of Daniel Webster's appears around the likeness: "Liberty and Union, Now and Forever, One and Inseparable." The empty cartridge box and scabbard on the monument's base symbolize Daniel Webster's dream of peace.

fight, it captured the flags of the Twenty-third North Carolina and the Twenty-sixth Alabama. The design of its monument, meant to represent the suffering of the soldier, features symbols of the life of a fighting man during the Civil War. The top contains a stack of those symbols, as if tossed aside by the soldier at the end of the fighting. A laurel wreath, designating victory, sits atop the pile. The entire monument is topped by an eagle.

A favorite challenge for school groups is to find as many of the symbols on the stack as possible. In case you are interested in trying to find them, the total number is nineteen.

Sergeant Edward Gilligan was awarded the Medal of Honor for his efforts in capturing the flag of the Twenty-third North Carolina.

## A-17: Iverson's Pits
**39º50.615'N, 77º14.575'W**

In the early afternoon of the first day's fighting, Brigadier General Alfred Iverson sent his brigade of North Carolina troops toward a location on Oak Hill where it was believed Union soldiers were massed. His plan was to strike the Northerners on their flank, but he was not aware of a brigade of Union troops hidden behind a

## A-18: Eighty-third New York Monument
**39º50.574'N, 77º14.537'W**

Organized in 1850 as the Ninth New York State National Guard, the Eighty-third New York is honored by one of the most unusual and impressive monuments on the battlefield. Twenty years after the war, veterans of the regiment visiting the battlefield expressed concern that New York had only two regimental monuments on the field, despite the fact that the Empire State furnished more troops at Gettysburg than any other state. They immediately began raising funds for their own monument.

stone wall that ran along what is now Doubleday Avenue. As Iverson's troops crossed the John Forney farm in perfect formation, the Union soldiers rose and fired almost as one, killing scores of Southerners with their first volley. The men of Iverson's brigade dropped where they stood, still in perfect formation. Within minutes, Iverson lost more than half his command.

The photo above shows the wall and the location of much of that devastation. Iverson's men were buried where they fell, just west of Forney's house. During the years following the war, the families of the dead had the bodies disinterred and moved south for reburial. But by that time, the locations of many of the graves had been lost. It is believed that many of Iverson's men are still buried in the field where they fell. Some call this one of the most haunted places on the battlefield.

In July 1888, their efforts came to fruition in one of the largest single monument dedications at Gettysburg. Recognizing their roots, the men of the Eighty-third New York included the name of the Ninth New York State National Guard on the memorial. The base includes the regimental badge and motto, *Ratione Aut Vi* ("By Reason or by Force").

## A-19: Eleventh Pennsylvania Monument
**39º50.530'N, 77º14.556'W**

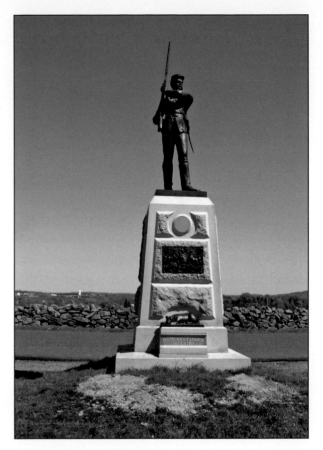

The photos on this page and on the left on page 18 exemplify the need to walk around the monuments and see what may be on the other side. Many who have driven along Oak Ridge will look at photos A-19 and say, "I remember that monument, but I didn't see a dog on it!" Those who view the monument to the Eleventh Pennsylvania Infantry only from the road will never see the dog, which lies on the rear side. The dog is Sallie, the Eleventh's mascot. Sallie followed the regiment throughout the war, and Gettysburg was no exception. A true soldier, she rushed into battle along with the rest of the Eleventh, barking at the enemy.

When the Union line, including the Eleventh Pennsylvania, collapsed on July 1, the regiment retreated in confusion. As they reorganized, the men realized Sallie was not with them. Two days after the battle, a burial detail found her lying among the regiment's dead, refusing to leave the side of her fallen master. Having had no food or water for four days, Sallie was in a weakened state. The men nursed her back to health, and Sallie remained with the regiment, rushing into battle at subsequent encounters. In February

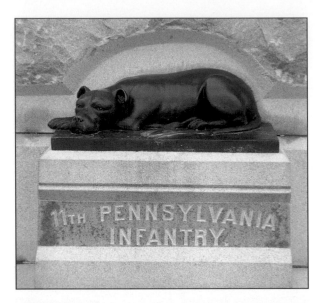

1865, Sallie died a soldier's death, shot through the head at Hatcher's Run, Virginia. The men of the Eleventh Pennsylvania included their mascot when it came time to place their monument, believing that no better symbol could be chosen to exemplify loyalty.

## A-20: Sixteenth Maine Monument
**39º50.495'N, 77º14.570'W**

The Sixteenth Maine Infantry arrived on the field around noon on the first day of the battle and immediately joined the fighting. Positioned near the intersection of Mummasburg Road and

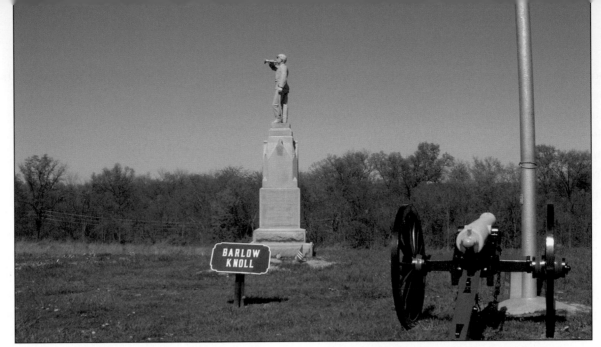

Doubleday Avenue, it held its ground for nearly three hours until forced to fall back toward town by the advancing Confederates.

The men were ordered to a new position at the approximate location of this monument, with orders to hold it at any cost. That was easier said than done. As the Sixteenth Maine was overwhelmed by the Southern troops, it was readily apparent the men would be forced to surrender. They quickly tore their flag into small strips, each man hiding a strip in his pocket so the captors would not be able to claim the colors as a spoil of war. Colonel Charles Tilden thrust his sword into the ground and snapped it into two pieces, also to keep it out of the hands of the Confederates.

It is said that many of those tattered remnants of the colors survive today in the families of the men who fought with the Sixteenth Maine. Perhaps no other act during the battle better illustrates the symbolism represented by regimental flags.

## A-21: Barlow Knoll
### 39º50.741'N, 77º13.569'W

Originally called Blocher's Knoll, this area became known as Barlow Knoll after the battle. On the afternoon of the first day, Major General Oliver O. Howard, taking command following the death of Major General John Reynolds, feared his right flank could be turned. To reduce that

possibility, he planned to extend the Union line beyond Oak Hill. Among the divisions given the directive to accomplish this was that of Brigadier General Francis Channing Barlow, age twenty-eight. Barlow chose to form his line on the high ground of Blocher's Knoll. Unfortunately for him, that position was too far forward to be properly supported by other Union forces, and his men were attacked from two sides by troops from Georgia. For two hours, the Confederates applied pressure, slowly driving Barlow's men back toward town. When the line broke, the retreat deteriorated into chaos.

The flagpole stands at the location where Lieutenant Colonel Douglas Fowler, commander of the Seventeenth Connecticut Infantry, was killed. It was placed there by survivors of the regiment several years after the battle.

The monument shown on page 19 is that of the 153rd Pennsylvania Infantry. Comprised mostly of Germans, the 153rd Pennsylvania had been part of the Eleventh Corps at Chancellorsville, where it was surprised by Thomas "Stonewall" Jackson's Confederate troops. The ensuing panicked retreat gave rise to the derisive nickname that would haunt the 153rd: "the Flying Dutchmen." Victims of poor positioning at Chancellorsville, the 153rd suffered much the same fate on Barlow Knoll. Its able performance in the war prior to Chancellorsville

and Gettysburg would forever be marred by its nickname.

## A-22: Francis Barlow Monument
**39º50.726'N, 77º13.586'W**

Under orders to extend the Union line, Brigadier General Francis Channing Barlow took his troops to the extreme right of the Eleventh Corps' position. As noted above (see photo A-21), Barlow's troops were hit hard on both flanks at about this location, forcing them to retreat. As Barlow attempted to rally his men,

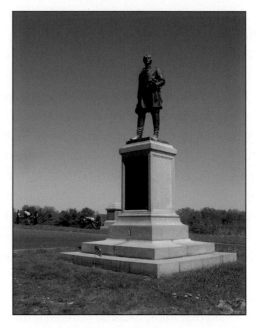

he was wounded in the side. Despite the heavy fighting all around him, Barlow dismounted and attempted to leave the field. When two of his troops tried to assist him, one was cut down and Barlow himself was wounded again, this time in the back. Barlow lay down in great pain. As he waited for death, he was wounded slightly for a third time, a bullet striking his right hand. Still another bullet passed through his hat.

Found by the Confederates, he was carried into the nearby woods, placed on a bed of leaves, given some water, and allowed to rest, after which he was carried in a makeshift stretcher to the nearby farmhouse of Josiah Benner. Later that evening, three Confederate surgeons arrived and probed his wounds. After determining that his prognosis was not good, they gave him morphine to make him comfortable while he awaited the inevitable.

Surprised to see that he was still alive the next day, his captors moved him to another house, where captured Federal surgeons examined him and reached the same conclusion as the Confederate doctors the previous day. When Federal authorities learned of Barlow's condition, his wife, Arabella, who was serving as a nurse nearby, was brought to the battlefield. Arabella began to nurse her husband back to health, just as she had when he was wounded at Antietam. Her efforts were rewarded when Barlow became strong enough to rejoin the Army of the Potomac in the spring of 1864. Her husband now recovered, Arabella returned to her duties with the Sanitary Commission.

Several years after the war, a story began to circulate that John Gordon, a Confederate brigadier general, had found Barlow wounded and left for dead. It was said that Gordon stopped in the middle of directing an attack to assist Barlow, sending word through the lines to Arabella that her husband was mortally wounded. Years later, when Gordon and Barlow supposedly met at a dinner party, each was surprised that the other had survived, and they became close friends. Although this makes for an interesting tale, Barlow maintained that the meeting with Gordon never actually happened.

## A-23: Alms House Cemetery
### 39º50.693'N, 77º13.641'W

The Alms House was the home for the poor and indigent of Adams County. This cemetery was the final resting place for those who had no families to claim their bodies after death. The cemetery was the scene of the fighting on July 1 between Brigadier General Francis Channing Barlow (see photos A-21 and A-22) and Confederate troops under Brigadier General George Doles. Several pieces of Union artillery were positioned within the boundaries of the

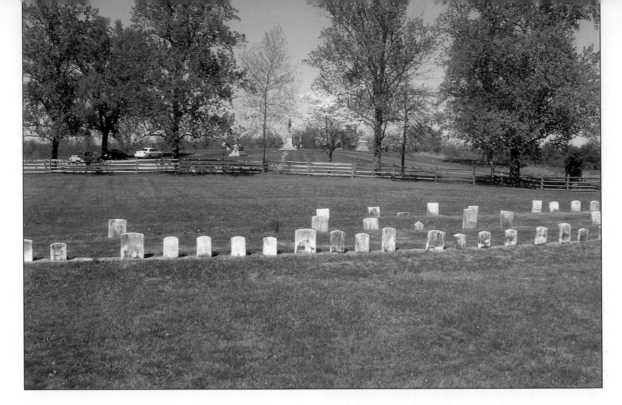

cemetery. The Confederates broke Barlow's line near this location, forcing the Union troops back into town in a chaotic retreat.

## A-24: Lee's Headquarters
**39º50.090'N, 77º14.729'W**

The photo on the right and the one on page 23 illustrate another of the battlefield's numerous controversies. Situated across U.S. 30 (Chambersburg Pike) from one another, both have been put forward as the site of Robert E. Lee's headquarters, and both appear to have

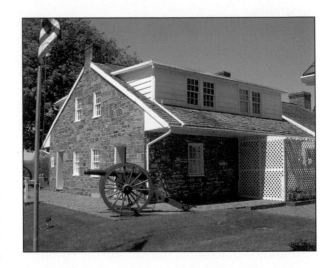

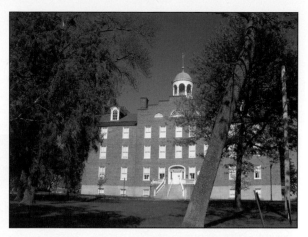

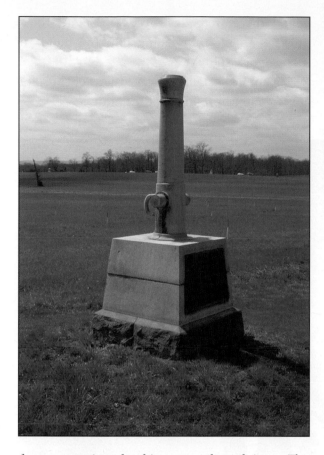

## A-25: Lutheran Theological Seminary
**39º49.720'N, 77º14.669'W**

documentation backing up the claims. The National Park Service supports the claim that the upright cannon is closer to the actual site, believing that Lee's headquarters consisted of a tent in the field behind the cannon. On the other hand, affidavits say that Lee took his meals and slept in the Thompson House, shown in the other photo. Readers are free to draw their own conclusions.

The Lutheran Theological Seminary, which gives Seminary Ridge its name, was a local landmark even before the battle. The main building in 1863, Schmucker Hall, is shown above. It served as both a dormitory and an administration building at the time of the battle.

Schmucker Hall took on added importance as an observation tower for both armies during the fighting. Brigadier General John Buford initially used the cupola to observe Confederate troops on the first day. When Union forces were driven off this part of the field, Confederate observers moved into the cupola. The current cupola is not

the one used during the battle. The original was destroyed by lightning in 1913.

Before the war, hidden rooms in the building's basement provided refuge for fugitive slaves on the Underground Railroad. Antislavery papers found there were destroyed by Union troops to keep them from falling into the hands of Confederate soldiers.

Schmucker Hall also served as a field hospital for two months following the fighting.

IN
TOWN

JENNIE WADE, AGED 20 YEARS 2 MONTHS
KILLED HERE — JULY 3, 1863
WHILE MAKING BREAD FOR THE UNION SOLDIERS

## B-1: Pennsylvania Hall, Gettysburg College
**39º50.117'N, 77º14.058'W**

At the time of the battle, the building pictured above was one of three buildings comprising the campus of Gettysburg College—or, as it was known then, Pennsylvania College. The cupola was used by both sides as an observation post and signal station. The building itself served as a field hospital for the wounded from both armies.

One of the soldiers treated at the hospital was a young Confederate prisoner named Lewis Powell. Powell eventually escaped and moved to Washington, D.C., where he also went by the name Lewis Paine. Powell/Paine became better known as one of the Lincoln assassination conspirators and was hanged for his part in the killing of the president.

Today, Pennsylvania Hall serves as the main administration building for the college. By congressional decree, a Civil War–era flag flies above it.

# B-2: Kuhn's Brickyard Mural
**39º50.108'N, 77º13.654'W**

Not heavily visited, the site of the Fight at the Brickyard—as this part of the battle became known—sits on a dead-end street away from the more heavily traveled parts of Gettysburg. Its remote location makes it no less important to the first day's fighting.

When the Eleventh Corps came under heavy fire, Colonel Charles Coster was ordered to move his brigade of Union infantry and a battery of artillery from Cemetery Hill to provide assistance. As Coster's troops reached Kuhn's Brickyard, two brigades of Jubal Early's division, commanded by General Harry Hayes and Colonel Isaac Avery,

also appeared. The two sides spotted each other at about the same time and began firing. Coster's men were overrun and retreated through the streets of town. Although relatively short, the battle claimed 770 casualties. Nearly 40 percent of Coster's men were taken captive.

Kuhn's Brickyard was much more remote than it is today. The area was largely an open field with few buildings. The structure on which the mural was painted was not here at the time of the battle. The rural setting is reflected in the mural, which depicts the fighting that took place here. The monument in the left center of the photo on the left is that of the 154th New York, one of the regiments involved in the fighting.

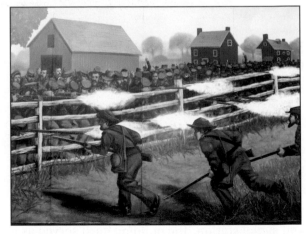

# B-3: Amos Humiston Monument
39º49.921'N, 77º13.722'W

Only one enlisted man has his own monument at Gettysburg. That man is Amos Humiston. His monument did not come about as the result of any particularly heroic deed he performed under fire. Humiston, a sergeant in the 154th New York Infantry, was killed on the first day of fighting when his regiment was overrun at Kuhn's Brickyard (see photos B-2). When his body was found, he was clutching a photo of his three children: Frank, age eight; Alice, age six; and Freddie, age four. No names appeared on the photo, and Sergeant Humiston carried no identification. It appeared that the body would be one of many unknown Union soldiers, that of a man who died looking at the images of his children.

The photo fell into the hands of Dr. John Bourns, who was caring for the wounded after the battle. The Philadelphia doctor might have merely wondered at the story behind the photograph, but he chose instead to try to learn the identities of the children, and perhaps that of their father. He contacted the *Philadelphia Inquirer,* which ran a story on the three mystery youngsters, calling them "the Children of the Battlefield." Because newspapers did not publish photos at that time, the *Inquirer* had to rely on detailed descriptions

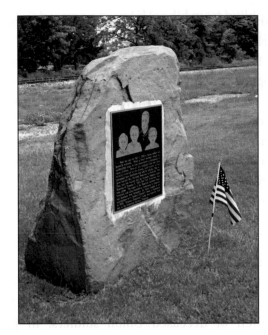

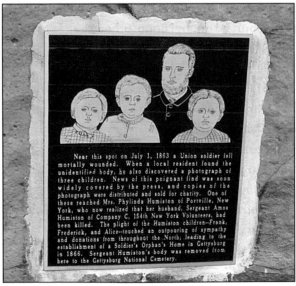

Near this spot on July 1, 1863 a Union soldier fell mortally wounded. When a local resident found the unidentified body, he also discovered a photograph of three children. News of this poignant find was soon widely covered by the press, and copies of the photograph were distributed and sold for charity. One of these reached Mrs. Phylinda Humiston of Portville, New York, who now realized that her husband, Sergeant Amos Humiston of Company C, 154th New York Volunteers, had been killed. The plight of the Humiston children--Frank, Frederick, and Alice--touched an outpouring of sympathy and donations from throughout the North, leading to the establishment of a Soldier's Orphan's Home in Gettysburg in 1866. Sergeant Humiston's body was removed from here to the Gettysburg National Cemetery.

The night before the dedication, Lincoln stayed at the Wills House, where he finalized the text of the remarks he would make the next day. Those remarks have become known as the Gettysburg Address, one of the most beloved speeches in our nation's history. The room where Lincoln stayed and completed his speech is marked by an arrow.

The square where the Wills House stands has since been named Lincoln Square in the president's honor. The house is open to the public as a museum.

## B-6: Lincoln Statue
**39º49.840'N, 77º13.846'W**

The statue on the town square depicts a lifelike Lincoln pointing toward the Wills House, as if showing a visitor the room where he stayed when he came to Gettysburg in November 1863 to dedicate the new cemetery. Titled *Return Visit*, it is one of the more highly photographed locations in the downtown area.

A highlight of the dedication was to be a speech by famed orator Edward Everett, who spoke for two hours. In his invitation to Lincoln to attend, David Wills wrote, "It is desired that, after the Oration, you, as Chief Executive of the Nation, formally set apart these grounds to their Sacred use by a few appropriate remarks." Those few appropriate remarks, taking only slightly more than two minutes, became known as the Gettysburg Address.

## B-7: Shell in Wall
**39º49.863'N, 77º13.828'W**

The artillery shell pictured on page 33 remains embedded in the wall of a structure adjacent to the Wills House on York Street, just as it was in July 1863. It is visible beneath the window on the second floor, where it is marked with a small flag. Other buildings in Gettysburg have similar unexploded shells in their exterior walls, providing mute evidence of the intense artillery fire.

At the time of the battle, this building housed Tyson Brothers Photography, owned by Charles and Isaac Tyson. Ironically, the Tysons established themselves among the best-known photographers of the battlefield in the days following the fighting.

## B-8: Penelope
**39º49.758'N, 77º13.862'W**

The unusual photo on the right shows a cannon embedded in the sidewalk so that only the breech is visible. Visitors often wonder what its purpose is.

The cannon, a relic from the War of 1812, was

affectionately named Penelope. It was positioned in front of the office of the *Gettysburg Compiler*, the Democratic town newspaper. Prior to 1855, it stood upright and ready for action. The publisher of the *Compiler*, the outspoken Henry Stahle, had it fired for every Democratic election victory. The firing usually occurred late at night, following an evening celebration in which unknown but presumably large quantities of liquid refreshments were consumed. In 1855, however, an overly exuberant would-be artillerist overloaded Penelope with powder, and her barrel exploded when she was fired. Rather than send her to the trash heap, Stahle had her buried in front of the office for all to see, even though she could no longer be fired.

During the battle, passing Confederate soldiers speculated on the meaning of the buried cannon, assuming incorrectly that it had something to do with the fighting.

## B-9: Presbyterian Church of Gettysburg
**39º49.706'N, 77º13.859'W**

Four months after the battle, President Lincoln came to Gettysburg to participate in the dedication of the national cemetery. Following that, he attended a political meeting at this

church, accompanied by John Burns (see photo A-6). When the original church was torn down and replaced by the structure pictured on page 34 in 1962, Lincoln's pew was saved and reinstalled. It is marked with a bronze plaque. About a hundred years after Lincoln's visit, President and Mrs. Dwight D. Eisenhower became members of the church. Their pew is also marked with a plaque. The attendance of both Lincoln and Eisenhower gave rise to a nickname: "the Church of the Presidents."

In the days immediately after the battle, the church served as a hospital for wounded soldiers.

## B-10: Jennie Wade Birthplace
**39º49.647'N, 77º13.862'W**

Jennie Wade was born on May 21, 1843, in this home on Baltimore Street, just a few blocks from where she was killed by a sharpshooter's bullet (see photos B-14). Thus, she became the only civilian to die in the battle. Today, the building is the home of the United States Christian Commission Museum, which commemorates an organization that served the spiritual and temporal needs of Civil War soldiers. The house is open to the public. Guided tours are available.

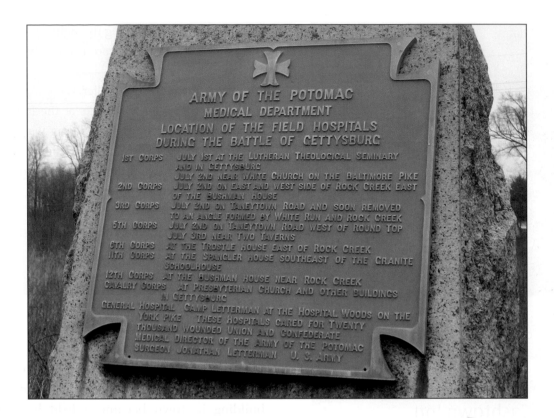

on the George Wolfe farm, just outside town on York Pike. The hospital was set up in a large field in sight of the railroad that was to bring both supplies and wounded men. Following treatment, those who were able were transported via rail to permanent hospitals in Baltimore, Washington, and Philadelphia. Hundreds of large tents were erected to house the wounded, and supply tents, cook tents, and surgical tents soon followed. A temporary morgue and cemetery were also put into place to handle the inevitable. More than

twelve hundred burials took place. In 1864, the Union dead were removed to the new national cemetery. The remains of Southern soldiers were relocated over the next several years to facilities nearer their homes.

Camp Letterman was the largest field hospital ever built in North America. But by November 1863, only a handful of patients remained. The camp was closed. Nothing remains of it today except for this tablet and a small adjoining wood lot.

Chapter 3
Area C

CEMETERY HILL

# Area C   Cemetery Hill

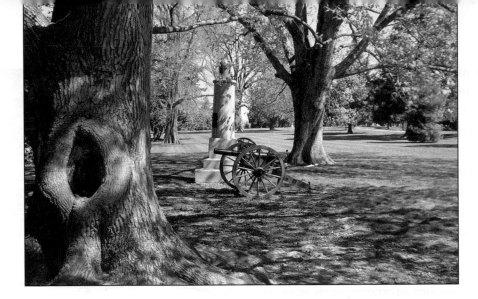

## C-1: National Cemetery

**39º49.063'N, 77º13.923'W**

At the time of the battle, the area now occupied by the national cemetery was a cornfield. Its elevation provided an excellent vantage point for artillery.

During and immediately after the fighting, many of the dead were buried where they lay or in the immediate vicinity. As a result, shallow graves appeared all over the battlefield. In many cases, the graves were so inadequate that the bodies became visible after the first rain. The need for a new cemetery was apparent. No cemetery in town was large enough to hold all the bodies that had to be reburied.

The original plan, laid out by landscape architect William Saunders, called for a series of semicircles holding the graves of Union soldiers, centered by a large memorial (see photos C-4). Graves were to be grouped by state. When it could be determined what state an unknown body was from, that man was buried with his named companions. In those cases where the state could not be determined, the body was buried in one of two sections dedicated to unknown soldiers. Of the more than thirty-five hundred Union soldiers buried here, nearly one-third have never been identified.

The bodies of Confederate soldiers generally were buried where they lay and were left there unless someone from the family or a friend came to transfer them for burial somewhere in the South. In the early 1870s, the Ladies Memorial Associations of several Southern cities began an effort to return all the Confederate dead to their respective cities and towns for reburial. More than three thousand bodies were transferred. As

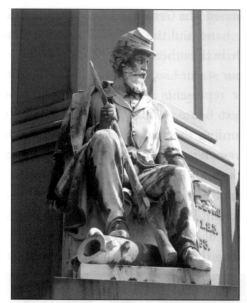

*War*

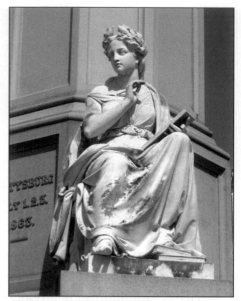

*History*

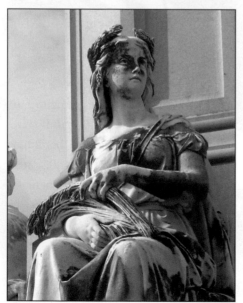

*Plenty*

*Peace*

rebuilding of the nation. It is interesting to note that the great majority of statues symbolizing Peace utilize the figure of a woman.

A panel on the back face contains a portion of Lincoln's Gettysburg Address.

## C-5: General John Reynolds Statue

**39º49.278'N, 77º13.820'W**

Dedicated in 1872, the figure of John Reynolds below was the first portrait statue erected after the battle. The high esteem in which he was held can be measured by the fact that he also has two other statues in his honor on the battlefield (see photos A-3 and A-10).

Several bronze cannons were donated by the state of Pennsylvania to be melted down and used to create the statue. The cemetery donated the space, as well as funds to construct the base. The statue was transported from Philadelphia free of charge. Still, the monument's cost was about fifteen thousand dollars, a high price for the time.

Reynolds is shown with his field glasses at the ready, gazing toward an unseen enemy.

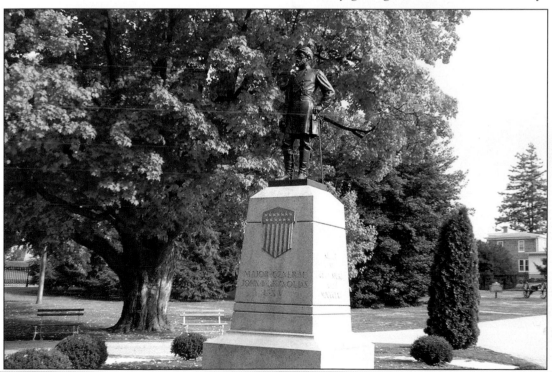

## C-6: New York State Memorial
**39º49.248'N, 77º13.835'W**

After New York's regimental monuments were in place, the state's monument commission chose to officially recognize and honor those from the Empire State who perished at Gettysburg. The memorial below, the tallest in the cemetery, was the result.

The name of every New York officer who died at Gettysburg is inscribed on a bronze plaque on the base. Above the plaque appear the badges for the individual corps in which New York soldiers served. The four battle scenes surrounding the base of the column are titled, "The Wounding of General Sickles," "The Wounding of General Hancock," "General Slocum's Council of War," and "The Death of General Reynolds." The four are separated by accouterments from the various branches of service. Various New York generals appear in the scenes.

The statue at the top of the column is taken from the New York State seal. The female figure is shown weeping for the dead. A floral wreath appears in her right hand, to be placed on the graves. She holds a staff in her left hand, topped by what is known as a "Liberty Cap," a form of stocking cap symbolizing freedom.

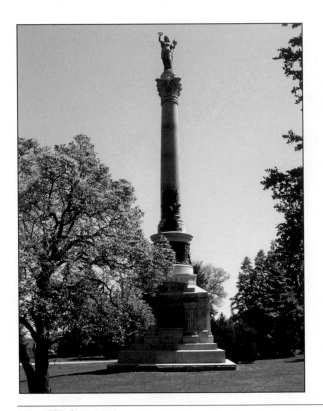

## C-7: The High Price of War
**39º49.160'N, 77º13.897'W**

Exact casualty figures for the battle are uncertain, particularly for the Confederate army, but this much is known: thousands of brave men on both sides paid the ultimate price. Union deaths are generally accepted at 3,155, while Confederate death figures range from 2,600 to 4,600. Using a median number of about 3,500, that would mean 6,000 to 7,000 from the two sides died in the battle.

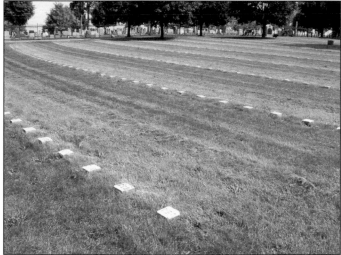

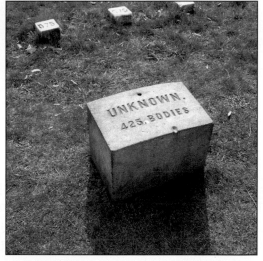

Unlike today, when soldiers wear dog tags, no standard means of identification existed during the Civil War. Many soldiers wrote their names and regiments on slips of paper and either pinned them to their uniforms or placed them in their pockets, and some enterprising sutlers sold brass identification tags that soldiers could wear around their necks, but most carried no identification. When a soldier was identified, or if he was unidentified but his state was known, he was buried in his state's section in one of the continuous arcs shown in the photo on page 49. Those who were not identified by their companions were buried as unknown soldiers, their families never knowing their fates. Their graves were marked with individual stones as shown in another photo on page 49, identified only by numbers on the tops of the stones. Each section of unknown dead was identified with a marker showing the number of bodies interred there.

## C-8: Friend to Friend Masonic Memorial
**39º49.258'N, 77º13.906'W**

Many officers on both sides of the battle belonged to the Free and Applied Masons, a fraternal organization that still exists today. Generals Winfield Scott Hancock of the Union and Lewis Armistead of the Confederacy were members. The two had been good friends prior to the war. As fate would have it, Armistead led his Confederates over the wall at the Angle in the assault known as Pickett's Charge. The men defending that wall were serving under Hancock. When Armistead was mortally wounded, he asked that his regards be sent to his old friend Hancock (see photo C-11).

The monument depicts the dramatic moment when Armistead gave Union captain Henry Bingham, himself a Mason, his personal effects to take to Hancock. Bingham, who was eventually promoted to general, promised to do so, even though Hancock had also been wounded. Thus, the theme of the monument is that Masons were brothers no matter which uniform they wore.

Although Hancock survived his wounds,

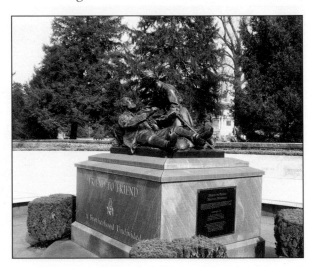

Armistead did not. The two did not see each other before Armistead died.

The names of every state that participated in the battle are listed around the inside perimeter of the memorial.

## C-9: National Cemetery Entrance
**39º49.289'N, 77º13.790'W**

Dedicated on November 19, 1863, the national cemetery is best known as the reason for Lincoln's famed Gettysburg Address. The president traveled up Baltimore Street from the Wills House (see photo B-5), entered the cemetery where the modern entrance below is located, and gave his famous speech as part of the dedication ceremonies. This was our first national cemetery.

Although it contains the remains of soldiers from all our wars from the Civil War to Vietnam, it is no longer open for burials.

## C-10: General O. O. Howard Monument
**39º49.314'N, 77º13.733'W**

General Oliver Otis Howard, commander of the Eleventh Corps, was a study in contrasts. Although he was a West Point graduate and an officer willing to kill the enemy, he was also a deeply religious man who was considering becoming a minister when the war began. He lost his right arm at Fair Oaks. His empty sleeve is visible on his monument.

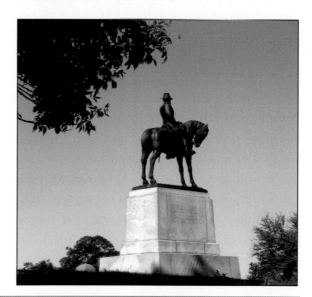

Howard's troops were the first to occupy Cemetery Hill, arriving around noon on the first day of fighting. Here, Howard quarreled with Major General Winfield Scott Hancock about who would be in command. Although Hancock had been sent by Major General George G. Meade with written orders to take command, Howard was adamant that he was the ranking general present. He eventually allowed Hancock to take over, albeit reluctantly.

Under Howard's command, the Eleventh Corps was thought by many to be one of the least reliable and effective corps in the Army of the Potomac. The collapse of the corps on the first day of fighting was blamed in part on Howard. In September, Howard's corps was reorganized into the Army of the Cumberland. However, many also believe that Howard's decision to rally his troops on Cemetery Hill was one of the best tactical decisions of the entire battle, buying time for the rest of the Union army to arrive and repulse the Confederates.

A strong advocate for education, Howard helped establish Howard University in Washington, D.C. He served as president of the school for five years.

## C-11: General Winfield Scott Hancock Memorial
**39º49.277'N, 77º13.733'W**

Known as "Hancock the Superb," Winfield Scott Hancock was one of the most respected generals in the Union army. Although Hancock was not the most senior officer at Gettysburg, General George Meade put him in command after Major General John Reynolds was killed on the first morning of the battle. This placed Hancock at odds with Major General O. O. Howard, who insisted he should be in charge, despite Meade's written orders. Hancock won the argument and went on to organize the Union forces on Cemetery Hill until Meade arrived on the field.

On the second day of fighting, Hancock rallied his troops as Lieutenant General A. P. Hill's Confederate forces attacked the Union line at the Wheatfield. Hancock placed his men in strategic locations that may have prevented the defeat of the Union army.

On July 3, Hancock held a position on Cemetery Ridge, the focal point of Pickett's Charge. During the infantry assault, Hancock was

wounded. His old Confederate friend, Brigadier General Lewis Armistead, was mortally wounded just yards away. Hancock refused to be evacuated to a field hospital until the battle was resolved, providing not only guidance but inspiration to the men under his command.

Hancock received the official gratitude of Congress for his gallantry at Gettysburg.

## C-12: Cemetery Hill
**39º49.282'N, 77º13.724'W**

Cemetery Hill became a rallying point for the Union army following its retreat into town late in the afternoon on July 1. As the Union reorganized, Robert E. Lee gave orders to Lieutenant General Richard Ewell to take Culp's Hill and Cemetery Hill "if practicable." The leeway given to Ewell proved costly for the Confederates, as he delayed attacking until the second day of fighting, when Union troops were firmly entrenched. The hill was the scene of bloody fighting as the Sixth, Seventh, and Ninth Louisiana regiments—better known as "the Louisiana Tigers"—and troops from North Carolina stormed the Union positions. At the summit, the fighting was hand to hand. The Union artillerymen threw rocks, swung artillery rammers, and even used their fists to defend their guns. The Confederates finally overran the

Union position, briefly taking command of the hill. Union reinforcements arrived and drove the Confederates back, retaking the strategic position and leaving the hillside strewn with dead and wounded.

Originally known as Raffensberger's Hill, the name informally changed when Evergreen Cemetery was established in 1858. Cemetery Hill became the common name by the time of the battle. The view in the photo on page 54 is from the Union position.

way up Cemetery Hill at dusk. The monument at the top of the hill is that of Major General O. O. Howard, commander of the Eleventh Corps.

By the time the attack was in full swing, it was so dark that Union soldiers could determine where the attackers were only by their rebel yells and the flashes of their guns. The action at the top of the hill became a free-for-all. Although the Confederates captured the hill, it was only temporary. Without reinforcements, the Southerners were forced to fall back, relinquishing their prize to the Union.

## C-13: General O. O. Howard Monument from Confederate View
**39º49.314'N, 77º13.733'W**

The photo on the left below shows the view the attacking Confederates had as they made their

## C-14: Base of Cemetery Hill
**39º49.294'N, 77º13.656'W**

Throughout the night of July 1 and well into the next morning, the Union army strengthened its position on Cemetery Hill. The base of the

hill, seen in the photo on page 56, was defended heavily by infantry, with three artillery batteries positioned at the top. In the general area shown in the photo, the Louisiana Tigers broke through the Union line and charged up the hill. The steep slope can be plainly seen. The charge was made in darkness under heavy fire and thick smoke. Troops had difficulty determining who was a friend and who an enemy, as both sides intermingled in the chaos. At the battle's end, bodies in blue uniforms lay side by side with bodies in gray, giving mute testimony to the ferocity of the fighting.

## C-15: Culp's Hill As Seen from Cemetery Hill
**39º49.253'N, 77º13.733'W**

Looking from the Union position on Cemetery Hill, the peaceful scene below does not tell

the story of the bloody fighting that took place on the night of July 2, 1863. Lunettes, the small mounds of dirt in front of the cannons, afforded some protection to the artillerists. But not enough, as Confederate troops overran the position, only to be driven back when Union reinforcements arrived.

## C-16: Fourth Ohio Infantry Monument
**39º49.257'N, 77º13.724'W**

As with many monuments on the battlefield, the Fourth Ohio's is as interesting for its history as for its appearance. When the regiment's veterans' association was deciding on the design of its memorial, it chose to have it constructed of "white bronze." This material was said to possess many outstanding qualities that would make it ideal for such a monument: it wouldn't discolor as would straight bronze, nor would it chip or crumble as granite would. It was also cheaper than granite. It seemed like the perfect material.

What wasn't known, or at least wasn't told to the regiment, was that white bronze was not strong. That shortcoming led to some significant problems. The original monument had a similar column and soldier, but the weight caused cracks in the white bronze base. By the mid-1970s, the soldier had tilted so badly that it was in danger

of toppling onto anyone unfortunate enough to be standing near the base, so the monument was replaced.

The memorial itself is quite impressive. It is placed where the Fourth Ohio helped repel the Confederate assault of East Cemetery Hill the evening of July 2. A soldier stands at parade rest at the top of a large column, which in turn sits on a base whose capstone features the state seal, a stack of muskets, a grouping of battle flags, and an eagle perched on a stack of various accouterments of war.

Shortly after the Fourth Ohio dedicated its original monument in 1887, the Gettysburg Battlefield Memorial Association, unhappy with the appearance of the white bronze, decreed that all monuments after that would be constructed of granite or pure bronze.

## C-17: Evergreen Cemetery
**39º49.250'N, 77º13.759'W**

Many visitors are surprised to learn that Evergreen Cemetery and the national cemetery are not one and the same. Sitting side by side and divided by only a wrought-iron fence, they appear to some to be a continuous property. But they are distinctly separate entities.

Evergreen Cemetery was well established at the time of the battle. Photos of the gatehouse can be seen in many period views as the fighting raged around the entrance on the first and second days. The cemetery's presence gave rise to the designation of the area as Cemetery Hill.

When the battle was over, the cemetery bore witness to the carnage that had taken place on its grounds. The gatehouse suffered damage from artillery shells, and dead men and horses littered the cemetery itself. Many of those men were buried by the cemetery caretaker, the pregnant Elizabeth Thorn (see photos C-18).

In a touch of irony, a sign at the gate at the time of the battle promised prosecution for anyone caught bringing a firearm into the cemetery.

## C-18: Civil War Women's Memorial
**39º49.229'N, 77º13.760'W**

Dedicated in 2002, this unusual monument is one of the newest in Gettysburg. Its purpose is to honor all the women who served in any capacity during and after the battle. It depicts a young immigrant cemetery caretaker named Elizabeth Thorn, who lived in the cemetery's gatehouse (see photo C-17) with her parents and

the war. They stayed at Evergreen Cemetery until 1874. Elizabeth's Gettysburg memoirs, written many years later, are considered among the best civilian accounts of the battle. She is buried in the cemetery she called home throughout the war.

## C-19: Jennie Wade Grave
**39º49.182'N, 77º13.820'W**

Virginia "Jennie" Wade was the only civilian to lose her life during the battle (see photos B-14). Struck by a stray bullet from a sharpshooter's gun as she prepared to bake bread, she died instantly. The next day, she was buried outside the house owned by her sister, Georgia. Jennie had come to

three young children. Her husband, Peter, was part of the Union army at Harpers Ferry during the Battle of Gettysburg.

Elizabeth Thorn served as a guide for General O. O. Howard on the evening of the first day. She cooked and baked for the Union soldiers until she and her family were forced to evacuate because of the heavy shelling. When she returned, she was devastated by the destruction. Despite being six months pregnant, she buried nearly a hundred men in the July heat. The only assistance she got was from her elderly parents. The monument shows her taking a short respite from her unpleasant task.

Elizabeth Thorn continued to run the cemetery until 1865, when her husband came home from

Georgia's home to help her sister as she recovered from giving birth. A year later, Jennie's body was removed to a cemetery in town. After the war, it was moved again to this location in Evergreen Cemetery. The flag at her grave is authorized to be flown twenty-four hours a day.

## C-20: Battle-Damaged Headstones

**39º49.152'N, 77º13.870'W (Culp) and 39º49.159'N, 77º13.833'W (Huber)**

When Union troops massed on Cemetery Hill, it was inevitable that some of the headstones in Evergreen Cemetery would receive battle damage. The stones below show the effects of the shelling and illustrate how war is no respecter of either the dead or the living.

The Culp headstone (left photo) marks the grave of Esiah Jesse Culp, one of many Culps buried in Evergreen Cemetery. Esiah was the father of Wesley Culp (see the commentary for photos B-14).

The headstone of Frederick Huber (right photo) marks the final resting place of a Gettysburg native killed a year earlier at the Battle of Fair Oaks. Initially buried on the battlefield, Frederick was brought home by his father, Dr. Henry S. Huber.

a soldier—not in 1863, at any rate. He was a veteran of the War of 1812. When the battle began, he donned his swallow-tailed coat and best shirt and hat and walked in the direction of the fighting, carrying an old musket. Known locally as a bit of a character, he joined in with the Iron Brigade and fought as a private citizen near the McPherson Farm, where he was wounded. His actions made him a national hero. He even received the personal thanks of President Lincoln. On his death, he was laid to rest in this plot in Evergreen Cemetery.

## C-21: John Burns Grave
**39º49.159'N, 77º13.825'W**

John Burns (see photo Λ-6) was one of the more colorful characters the battle produced. But the seventy-two-year-old Burns wasn't even

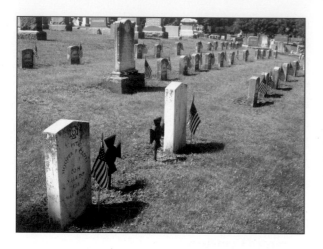

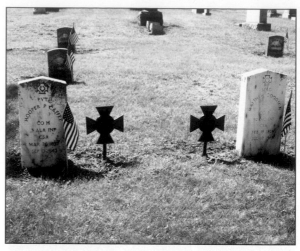

## C-22: Union and Confederate Graves
**39º49.177'N, 77º13.753'W**

When the battle was over and Elizabeth Thorn (see photos C-18) returned home, she faced total devastation. Dead soldiers lay as far as the eye could see. As caretaker of Evergreen Cemetery, the pregnant Elizabeth faced the responsibility of burying the dead, despite the extreme heat. Union or Confederate, it mattered not. She personally buried as many as a hundred soldiers. Most of the Confederates were later removed to their homes for reburial, but for those who had no family to claim their bodies, Evergreen Cemetery became their final resting place. Here, over 140 years after the sounds of battle ended, soldiers from both sides lie side by side, united in death.

In viewing the headstones, note that the Union stones are rounded on top, while those on Confederate graves come to a point. Legend has it that the Confederate headstones were made in that design so Yankees could never sit on them.

Chapter 4
Area D

CULP'S HILL

# Area D    Culp's Hill

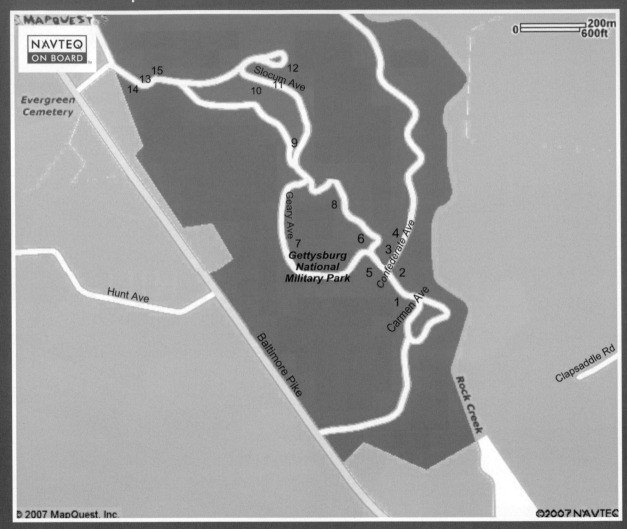

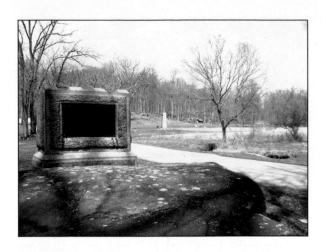

## D-1: Second Massachusetts Infantry Monument
**39º48.809'N, 77º12.972'W**

This small, easily missed monument at the edge of Spangler Meadow was the first regimental monument erected on the battlefield. Dedicated in 1879, it commemorates the fateful charge of the Second Massachusetts, alongside the Twenty-seventh Indiana, late in the morning on July 3 in an attempt to force the Confederates out of the defensive positions they had taken from the Union the evening before. When orders for an all-out attack came, Lieutenant Colonel Charles Mudge said, "Boys, it is murder. But these are our orders."

On Mudge's order to advance, 316 officers and men of the Second Massachusetts raced into the open meadow to the right rear of the monument, only to be met by withering fire from the entrenched Confederates in front of them and to their left. Four officers and 45 men were killed in the charge and countless others wounded. Among those killed was Lieutenant Colonel Mudge.

## D-2: Spangler Meadow
**39º48.847'N, 77º12.978'W**

Sitting at the base of Culp's Hill, Spangler Meadow is often overlooked by visitors who come to the area to see the better-known Spangler's Spring. Spangler Meadow is easily identified by the Indiana State Memorial, the large monument shown below.

The meadow was the scene of an ill-fated charge by the Second Massachusetts (see photo D-1) and the Twenty-seventh Indiana. The small

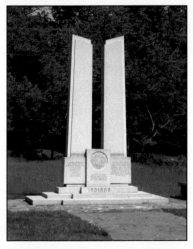

marker in the middle of the field notes the farthest point reached by the Twenty-seventh Indiana. Eight color bearers from the Twenty-seventh were cut down in the charge, and nearly one-third of the regiment became casualties. The boulder on which the regimental monument sits was used as shelter for some of the wounded as they made their way back to the woods after the unsuccessful charge.

## D-3: Culp's Hill
**39º48.860'N, 77º12.993'W**

Located at the "hook" end of the famed fishhook-shaped Union line, Culp's Hill was the location of the extreme right flank of the Union army, making it vulnerable to attack. The general consensus at George G. Meade's council of war was that the Confederate army would have to be forced out of the area. Failure to do so would jeopardize the use of the Baltimore Pike, the road in the rear of the Union army.

The Confederates also knew the strategic importance of Culp's Hill and were just as determined to maintain their presence there.

Action began in the early-morning hours of July 3 when the Union launched a surprise attack on the advancing Confederates. After several hours of bloody fighting that left the hillside littered with bodies from both sides, the Federal troops drove the Confederate army off, leaving

the hook end of the fishhook safe for the Union army.

The fight for Culp's Hill had an impact on the remainder of the battle as well. Robert E. Lee believed that Meade had sent reinforcements to his flanks, including Culp's Hill, from the center of his line. If that were true, Lee surmised, the center would be the weakest point along the entire Union line. He decided to attack at that point. Thus, the stage was set for Pickett's Charge.

## D-4: Coble Rock
**39º48.902'N, 77º12.981'W**

Although relatively difficult to locate, this rock carving is an interesting side story to the battle. One of the Confederate regiments engaged in the heavy action for Culp's Hill was the First North Carolina Infantry. Fighting near the base of the hill not far from Spangler's Spring, the First North Carolina suffered heavy casualties. Among

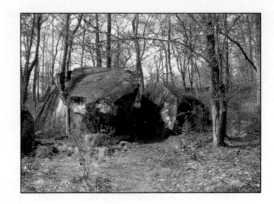

the survivors was Private Augustus L. Coble, one of the regiment's flag bearers. Sometime after the war, possibly at one of the veterans' reunions, Coble returned to Culp's Hill, found his position during the battle, and carved his name and regiment on the rock.

To view the rock and the carving, it is easiest to leave your car in the small parking area adjoining Spangler's Spring (see photo D-5), then walk back down the road between the tree line and Spangler Meadow (see photo D-2). A short distance from the Indiana State Memorial sits a small stone wall, through which the road passes. Just before reaching the wall, you will see several large boulders on the left. Often, a visible path leads to the boulders. One of the boulders gives the appearance of having split into two pieces. Go into the split, where you will note a smaller boulder at the far end. On the level, flat surface is the carving. It is difficult to see, so you will have to look closely. The carving may be outlined

in chalk to make it more visible. Please take care to avoid walking across the carving, as it is gradually being worn away by weather and the feet of visitors.

## D-5: Spangler's Spring
**39º48.873'N, 77º13.037'W**

Spangler's Spring had long provided water at the southern end of Culp's Hill. During the battle, it became a lifeblood for soldiers from both sides. On July 2, 1863, the men of the Union's Twelfth Corps occupied the area and used Spangler's Spring to quench their thirst and fill their canteens as they hastily threw up breastworks for the defense of Culp's Hill. When the Union's left flank was in danger of being overrun, the Federals immediately left the spring and marched toward the Peach Orchard, leaving the area unattended. Later that evening, Confederate troops from

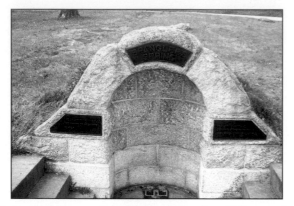

Brigadier General George H. "Maryland" Steuart's Brigade moved into the abandoned breastworks and availed themselves of the waters of Spangler's Spring. When fighting resumed during the night, the area was hotly contested.

The next morning, a Union counterattack made it hazardous to try to reach the spring, as it stood in a no man's land between the two armies. By the morning of July 3, Union troops controlled the area around the spring and thus regained the water.

It has often been said that soldiers from both armies used the spring at the same time during the night of July 2, conversing and trading tobacco and coffee during an unofficial truce. This is probably not factual, considering the fierce fighting that took place in the area, but the story continues.

The site looks different today from the open spring that existed in 1863. After the battle, the many visitors to Spangler's Spring caused extensive damage to the banks and covers. The present structure was built to protect the spring from further damage. At one time, visitors were permitted to drink from the spring, but that practice is no longer allowed due to potential ground water contamination.

## D-6: Wall above Spangler's Spring
**39º48.915'N, 77º13.032'W**

The serene scene below on Culp's Hill shows the site of the extreme right flank of the Union army during the battle. It formed the barb of the famed "fishhook" defensive line. Its importance came from its strategic location above Cemetery Hill and the Union supply route along the Baltimore Pike. The wall in the photo was likely not there during the battle but was probably built later by farmers. The remains of breastworks can still be seen, however. As illustrated by this photo, the beauty of the area has not changed.

At the end of the first day's fighting, the Union occupied this area just above Spangler's Spring. Lieutenant General Richard S. Ewell had been given discretionary orders from Robert E. Lee to take Culp's and Cemetery hills "if practicable." Ewell chose not to act, one of the greatest missed opportunities of the battle for the Confederate army.

When the Confederates finally moved onto Culp's Hill around eight o'clock on the evening of July 2, they found the area nearly unoccupied, the Twelfth Corps having been moved to reinforce the Union's left flank. A small brigade under Brigadier General George Greene (see photo D-12) struck the unsuspecting Confederates as they climbed the slopes around this area. For several hours during the night, the two sides attacked and counterattacked until the Union was able to claim the hill early on the morning of July 3.

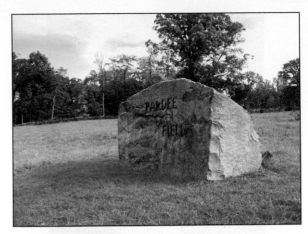

their entrenchments behind the stone wall at the rear of the field. A counterattack across this same field represented the final Confederate surge for the hill. To illustrate the ferocity of the fighting, Brigadier General John Geary of the Union reported that nearly twelve hundred Confederates were killed in this small field. Nine hundred of them were buried by Federal soldiers, and perhaps four times as many were wounded. An additional five hundred were captured.

## D-7: Pardee Field
**39º48.943'N, 77º13.179'W**

As both armies attacked and counterattacked in the prolonged fight for Culp's Hill on the morning of July 3, some of the most vicious action spilled over onto the lower part of the hill into the area shown in the photo above. The 147th Pennsylvania, under the command of Lieutenant Colonel Ario Pardee, mounted a charge across this open terrain to drive the Confederates from

## D-8: Twenty-ninth Pennsylvania Monument
**39º49.009'N, 77º13.107'W**

On the morning of July 2, the Twenty-ninth Pennsylvania took its position in a wooded area to the right of the Baltimore Pike. That evening,

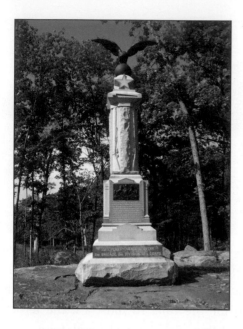

Union position before being driven back. When its ammunition was exhausted, the Twenty-ninth pulled back, replaced by the First Maryland.

The regiment returned to its original position in midafternoon and fought throughout the rest of the afternoon and evening. Fifteen of its number were killed, forty-five were wounded, and fourteen were declared missing during the three days of fighting.

The Twenty-ninth participated in the pursuit of General Lee's army following the battle.

## D-9: General John Geary Monument
**39º49.033'N, 77º13.196'W**

General John White Geary's Twelfth Corps was intensely engaged in the fighting for Culp's Hill on July 3, from the beginning of the attack at dawn until late in the morning, when the Confederates were pushed off the hill.

Wounded six times over the course of the war, Geary commanded the Second Division of the Twelfth Corps at Gettysburg and later served as mayor of San Francisco, governor of Kansas, and governor of Pennsylvania. In 1913, the Pennsylvania state legislature set aside fifty thousand dollars to erect monuments at Gettysburg honoring five native sons, Geary among them.

it moved to the left to serve as reinforcement for the Third Corps. Upon its return, it was met with a hail of bullets from Confederates who had moved into the area in the absence of the Twenty-ninth. Thinking the firing was from other Union forces, Colonel William Rickards shouted for them to hold their fire. When he identified himself, another volley ensued, leading Rickards to realize that Southern troops had moved in.

Rickards immediately formed his men in a line of battle. Shortly after three that morning, the fighting began in earnest. After about seven hours, a Confederate charge on the Twenty-ninth's position resulted in a bloodbath, the Confederates getting within ten paces of the

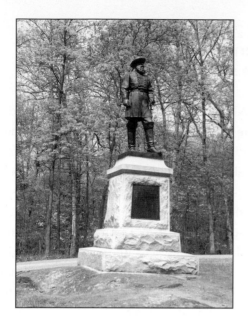

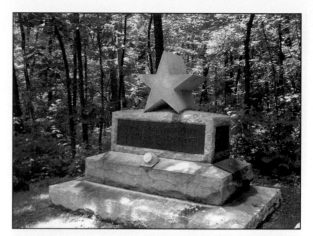

monument sits at the position held by the Twenty-eighth Pennsylvania Infantry from the morning of July 2 until it was ordered to reinforce the Union left that evening.

Known as "the Goldstream Regiment," the Twenty-eighth was organized by none other than General John Geary (see photo D-9), who paid for the regiment's uniforms and equipment. When more volunteers signed on than were needed, the surplus was formed into an artillery unit known as Knapp's Battery, which was attached to the regiment.

An oddity is associated with Geary's monument. Although the statue was erected in 1915, it was not formally dedicated until 2007.

## D-10: Twenty-eighth Pennsylvania Monument
**39º49.150'N, 77º13.211'W**

This monument is one of two on the Gettysburg battlefield devoted to the Twenty-eighth Pennsylvania. The other is located near Rock Creek. The monument in the photo above left is dominated by a large star in honor of the Twelfth Corps, to which the Twenty-eighth Pennsylvania belonged. The star was the corps insignia. The

## D-11: Seventy-eighth and 102nd New York Volunteers Monument
**39º49.110'N, 77º13.169'W**

This intricately carved monument is unusual because it honors two regiments. Both the

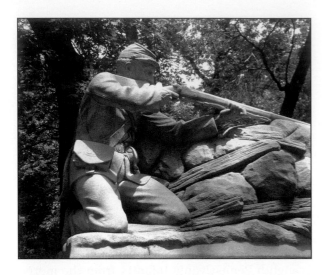

## D-12: General George Greene Monument
**39º49.192'N, 77º13.209'W**

Seventy-eighth and 102nd New York regiments suffered heavy losses prior to coming to Gettysburg, and both fought on Culp's Hill. They both took additional losses at Gettysburg.

Why one monument for two separate regiments? The answer is simple. Although they fought separately at Gettysburg, the two regiments were combined in the summer of 1864. When it came time to erect a monument, the decision was made to honor them as the combined unit they had become.

Many see something unusual in the carving. They claim the image of a lion's head is in the rock, symbolizing the bravery exhibited by the two regiments. The lion's head appears below the soldier's left hand, its paw below the fence rail.

In 1987, vandals smashed the rifle and right arm of the monument.

When most of the Twelfth Corps was ordered to the left of the Union line as reinforcements, Brigadier General George Sears Greene found himself alone on Culp's Hill with orders to defend his position at all hazards. Commanding a single brigade of New York regiments (the Sixtieth, Seventy-eighth, 102nd, 137th, and 149th), Greene stretched his line as thin as was practical. He had his men throw up breastworks, a practice opposed by many on both sides. He then dug in for the inevitable assault.

He didn't have to wait long, as Major General Edward Johnson's Confederate troops from Maryland, North Carolina, Virginia, and Louisiana began their ascent of the hill, not realizing that Greene's men were just in front of them. Using the darkness as an asset, Greene had his men wait until they could not miss. Their initial volley tore into the unsuspecting Confederates, forcing them back to regroup. The fighting continued until midnight, as Greene received assistance from units assigned to the First and Eleventh corps. Greene shifted his troops from place to place as they were needed until the fighting subsided, all the while riding up and down the line with little regard for his own safety.

Union forces mounted a counterattack early

the next morning and finally succeeded in driving the determined Confederates off the hill.

Greene's decision to defy conventional wisdom and place his troops behind breastworks probably saved Culp's Hill for the Union. Had his line broken, the Confederates would likely have turned the entire right of the Union line.

None other than a top Confederate general, James Longstreet, paid Greene the ultimate compliment, saying there was no better officer in either army. This monument depicts Greene pointing in the direction of the charging Confederates.

# D-13: Cemetery Hill Viewed from Stevens Knoll
**39º49.174'N, 77º13.490'W**

The night of July 2 saw Confederate troops under General Harry T. Hayes and Colonel Isaac Avery leave their positions on Culp's Hill and advance across this field to the base of Cemetery Hill, visible in the background. The attack on Cemetery Hill was under way. Several stone walls, some hiding Federal troops, stood between the Confederates and their objective. As they crossed this open expanse, they came under heavy artillery fire. Once at the base of the hill, they encountered the hidden Union troops, and heavy fighting, some of it hand to hand, began. The Southern troops temporarily captured the hill, but Union reinforcements drove them back. By midnight, the hill remained in Union hands.

The only difference was that the ground was now littered with the dead and wounded of both sides.

# D-14: Henry Slocum Monument
**39º49.146'N, 77º13.476'W**

Major General Henry Warner Slocum was known as a mild, nonassertive officer who did things by the book. As commander of the Twelfth Corps, he also was the ranking general on the field until Meade arrived after midnight on the first day.

Slocum's methodical style played a part in his not reaching the battlefield until late in the afternoon on the first day of fighting, much to the chagrin of other officers. This led to a derisive play on his name: "Slow Come."

When Meade ordered Slocum to send his corps to the Union left flank on July 2 to reinforce the defense against Longstreet's push, Slocum suggested he be permitted to hold his troops back on Culp's Hill. Meade agreed to allow Slocum to hold back one brigade. That brigade under Brigadier General George S. Greene proved to be instrumental in repulsing the Confederate assault.

# D-15: The Ferocity of the Battle
**39º49.174'N, 77º13.426'W**

Perhaps nothing better illustrates the ferocity with which the battle was fought than the somber inscription on the marker for the Iron Brigade's Twenty-fourth Michigan pictured below right. No additional words are necessary.

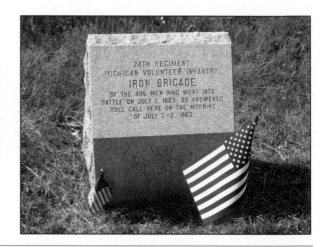

Chapter 5
Area E

WEST

CONFEDERATE

AVENUE,

NORTH END

# Area E  West Confederate Avenue, North End

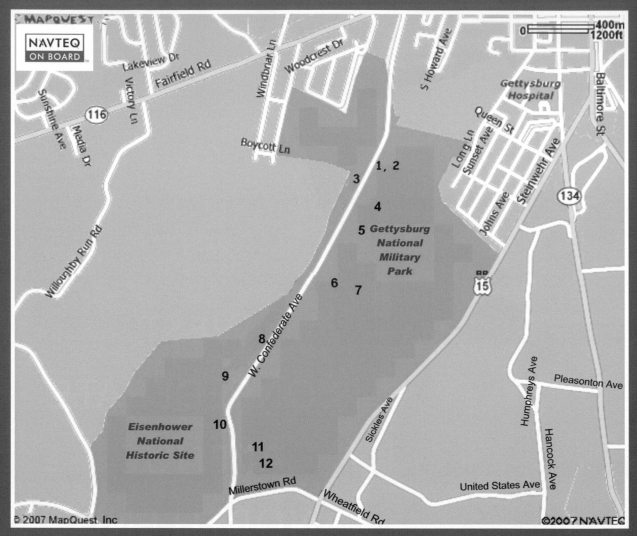

## E-1: West Confederate Avenue/ Seminary Ridge
**39°49.159'N, 77°14.827'W**

The Confederate batteries pictured above sit on the approximate location of those during the battle. They supported the attacks on Cemetery Hill on July 2, 1863, and on Cemetery Ridge the next day. They occupy a position on Seminary Ridge, named for the Lutheran seminary. The entire ridge provided excellent cover during the battle.

West Confederate Avenue contains most of the Confederate state monuments, as well as brigade markers showing Confederate positions. The avenue follows closely the line held by the Confederate army on July 3 as it assembled for the assault forever known as Pickett's Charge.

## E-2: Left Flank of Pickett's Charge, and Pickett's Charge Looking toward Codori Barn
**39°49.169'N, 77°14.813'W**

Believing the Union line would be weakest at its center, Robert E. Lee made plans for an attack at that location on the third day of fighting. Commanded by Lieutenant General James Longstreet, the attack was referred to as Longstreet's Assault, although the more commonly accepted name today is Pickett's Charge. Pickett's Charge is a misnomer, implying that all the troops were directed by General George Pickett, who actually commanded only the Virginia soldiers. General James J. Pettigrew and General Isaac Trimble also served as division commanders during the assault.

Just prior to Pickett's Charge, Confederate

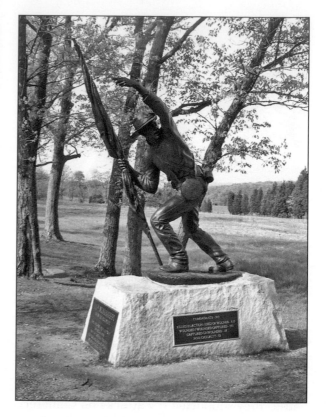

troops massed in the area where the photos with this section were taken. After a prolonged artillery barrage that could be heard more than a hundred miles away, the troops stepped off across these fields. Their goal was a small copse along Cemetery Ridge. The barn on the Codori Farm was a landmark that many troops advanced toward through the smoke of the battle. Few reached the stone wall near the copse; fewer still crossed it. The fierce hand-to-hand fighting at the wall ended with the Confederates being driven back. The repulse of the charge was the end of the Battle of Gettysburg.

## E-3: Eleventh Mississippi Infantry Monument
**39°49.128'N, 77°14.858'W**

The Eleventh Mississippi is honored by two monuments on the battlefield. The one above,

on Seminary Ridge, is near the point where the regiment formed on the afternoon of July 3 preparatory for the advance that would become known as Pickett's Charge. The second monument (see photo G-22), located near the stone wall next to the Brian barn, marks the regiment's farthest advance. The Eleventh Mississippi was decimated at Gettysburg. Of the 393 men who entered the battle, 340 were killed, wounded, missing, or captured.

The monument in the photo depicts Color

Sergeant William O'Brien of Company C raising his flag and urging his comrades to the charge.

## E-4: North Carolina State Memorial
**39°49.100'N, 77°14.837'W**

One of the earliest Confederate state monuments placed at Gettysburg was that of North Carolina, although it took sixteen years from conception to completion. In 1913, the North Carolina state legislature appointed a commission of veterans to return to Gettysburg and develop a plan for the monument. World War I derailed those plans, and it was not until 1927 that

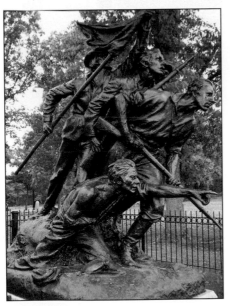

the monument once again became a viable project. It was finally dedicated in 1929.

The figures shown on the monument are those of a wounded officer directing his men forward and the troops crouching as they bravely face enemy fire. The faces were modeled from photographs of actual North Carolina veterans. The sculptor, Gutzon Borglum, also fashioned the faces of the presidents on Mount Rushmore.

One of every four Confederate soldiers who fell at Gettysburg was a North Carolinian.

## E-5: Tennessee State Memorial
**39°49.061'N, 77°14.873'W**

Dedicated on July 2, 1982, this was the last state monument placed on the battlefield. It was funded entirely by private contributions, the only state memorial with that distinction.

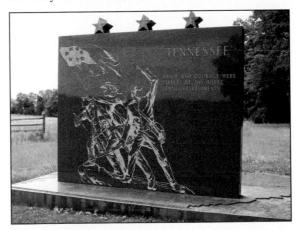

The monument has a great deal of symbolism. It is sixteen feet long, symbolizing that Tennessee was the sixteenth state to enter the nation. Look closely at the base and the outline of the state becomes apparent. The three soldiers on the monument represent the three Tennessee regiments at Gettysburg, and the three stars on the top stand for the three geographic divisions within the state: eastern, central, and western.

The Tennessee State Memorial was sculpted by Felix de Weldon, who also fashioned the Marine Corps War Memorial—better known as the Iwo Jima Monument—in Arlington, Virginia.

Tennessee troops formed near this site for Pickett's Charge. They experienced a 57.7 percent casualty rate at Gettysburg.

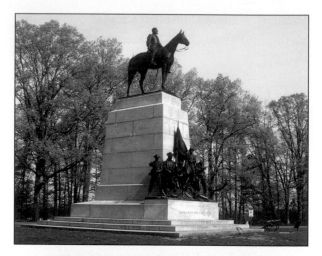

## E-6: Virginia State Memorial
**39°48.848'N, 77°15.019'W**

This was the first Southern monument to be placed on the battlefield, and it remains one of the largest. Dedicated in 1917, it jointly honors the soldiers from Virginia and their commander, General Robert E. Lee. The monument, placed at the location from which Lee observed Pickett's Charge, features Lee sitting on his horse Traveller.

At the base of the monument, seven figures represent the backgrounds of many Virginia troops: a professional man, a mechanic, an

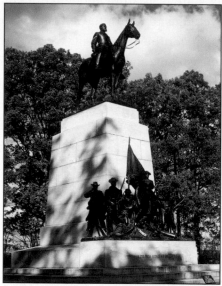

artist, a businessman, a farmer, and two young boys who appear as a bugler and a cavalry color bearer. Both sides used boys in those roles, as well as that of drummer.

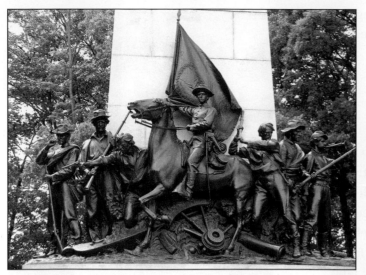

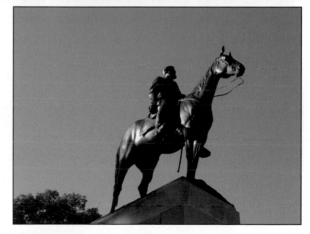

The lower left photo shows the shadow of General Lee as he may have appeared while awaiting the return of his troops after their ill-fated charge against the Union line along Cemetery Ridge. His eyes face those of his opponent, General George Meade (see photo G-25) on Cemetery Ridge.

The statue of Lee that sits atop the Virginia State Memorial (shown in closeup lower right) is duplicated on Richmond's famed Monument Avenue.

Virginia had more troops at Gettysburg than

any other Confederate state, contributing over nineteen thousand. Nearly one in four became a casualty.

## E-7: Lee Awaits His Troops
**39°48.779'N, 77°14.902W**

The scene pictured below is the approximate position Lee took as his battered troops retreated from Cemetery Ridge following the ill-fated assault known today as Pickett's Charge. Lee assumed full responsibility for the defeat, refusing to allow any of his generals to be blamed for the outcome, saying, "It's my fault. It's all my fault." And to General George Pickett, whose name is forever linked to the charge, he said, "Upon my shoulders rests the blame."

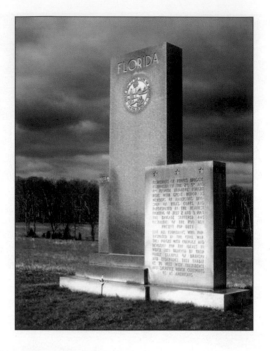

## E-8: Florida State Memorial
**39°48.606'N, 77°15.242'W**

Three regiments from Florida—the Second, Fifth, and Eighth—fought at Gettysburg. Their service is recognized by this memorial. The monument sits near the area occupied by the Florida Brigade. The center portion contains the seal of the state of Florida. Three stars, one for each of the three Florida regiments, adorn the smaller part of the memorial, accompanied by a short inscription. The three regiments brought 739 men into the battle and suffered 455 casualties.

## E-9: First United States Sharpshooters Monument

**39°48.489'N, 77°15.427'W**

The First United States Sharpshooters were often referred to as "Berdan's Sharpshooters," after their colonel, Hiram Berdan. Wearing distinctive green uniforms, they were expert marksmen. To qualify for the regiment, candidates had to demonstrate their shooting proficiency by hitting a target's bull's-eye on ten consecutive shots from a distance of two hundred yards.

These two monuments are both dedicated to Berdan's First Regiment of Sharpshooters. (Two regiments existed.) The monument to the left is dedicated to Companies A, B, D, and H from New York, which came to the aid of Company F, losing nineteen men in the process. The New Yorkers took an additional forty-nine casualties the next day at the Peach Orchard.

During the battle, the men of Company F (honored by the memorial in the photo below), comprised of Vermont troops, were sent to the front of the Third Corps, where they unexpectedly found themselves behind enemy lines. They encountered several Confederate regiments under General Cadmus Wilcox at this location, where fierce fighting ensued.

Their monument was badly damaged by a

falling tree during a storm in 1991. The shaft and eagle were shattered. Fundraising for the repairs took nine years, and it wasn't until 2000 that the restored monument was unveiled.

## E-10: General James Longstreet Monument
**39°48.334'N, 77°15.389'W**

This monument, dedicated in 1998, is unusual in that it is the only equestrian statue on the battlefield that does not sit on a pedestal. It is also the only monument dedicated solely to a Confederate general. While Robert E. Lee dominates the Virginia State Memorial, he shares it with the troops of Virginia.

Known as "Old Pete" and "Lee's Old War Horse," Longstreet was not in total agreement with Lee's offensive strategy at Gettysburg, and

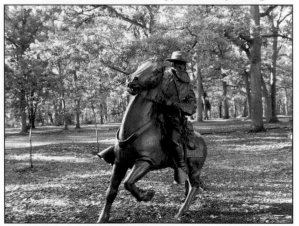

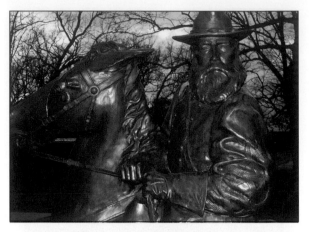

he reluctantly commanded what became known as Pickett's Charge. Openly critical of Lee after the war, Longstreet joined the Republican Party, much to the chagrin of Southerners, who saw the party as the primary reason the South was not treated well in the Reconstruction era. As a result, Longstreet became one of the more controversial figures of the former Confederacy. Although he was fiercely defended by those who fought under his command, he was vilified by others for his postwar activities. Many blamed him for the defeat at Gettysburg.

## E-11: Louisiana State Memorial
**39°48.178'N, 77°15.350'W**

This elaborate monument sits near the location occupied by the Washington Artillery of New Orleans on July 2, 1863. A fallen artilleryman, a

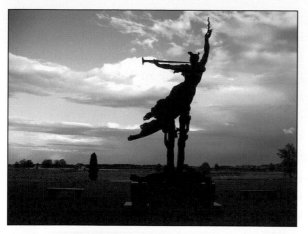

Confederate battle flag covering his chest, lies beneath a female figure known as "the Spirit of the Confederacy." She holds a flaming cannonball in her upraised right hand, symbolizing ordnance and artillery. The figure is said to represent Saint Barbara, the patron saint of the artillery. Beneath the Spirit of the Confederacy and above the fallen artilleryman is a dove, representing peace.

All of Louisiana's 3,031 troops who fought at Gettysburg are honored by this monument. The state suffered a 26.4 percent casualty rate.

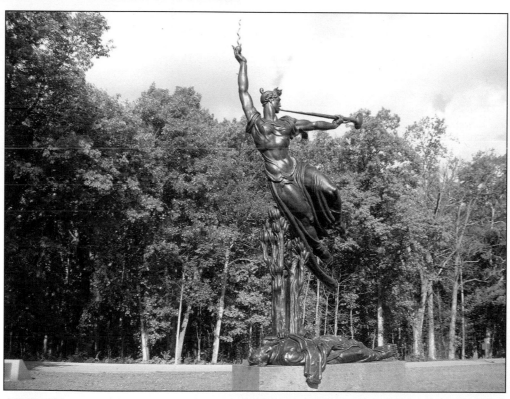

# E-12: Mississippi State Memorial
**39°48.144'N, 77°15.353'W**

The Mississippi State Memorial was placed at the location occupied by Brigadier General William Barksdale's Mississippi brigade late in the afternoon of the second day's fighting. It depicts two infantrymen of Barksdale's brigade advancing across the Sherfy and Trostle farms. A soldier is wielding his weapon as a club in an effort to protect his wounded comrade, who is grasping his flag. This scenario was not at all unusual in the brutal hand-to-hand fighting in this area. The Mississippians were able to break through the Union line at the Peach Orchard, only to be repulsed as they reached the Union center along Cemetery Ridge. They were said to have made "the most magnificent charge of the war," in the eyes of an observer. It did not come without cost. Of the state's 4,930 participants in the battle, more than one in three was either killed, wounded, or missing.

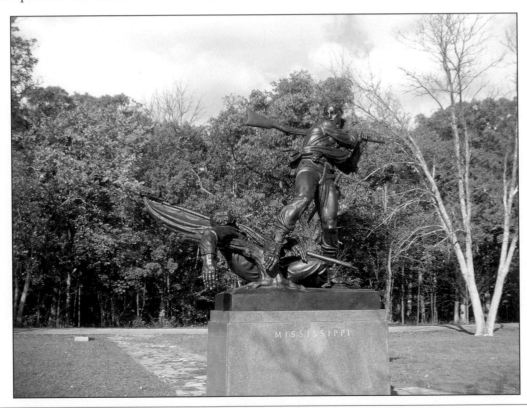

Chapter 6
Area F

# WESTCONFEDERATE
# AVENUE,SOUTHEND

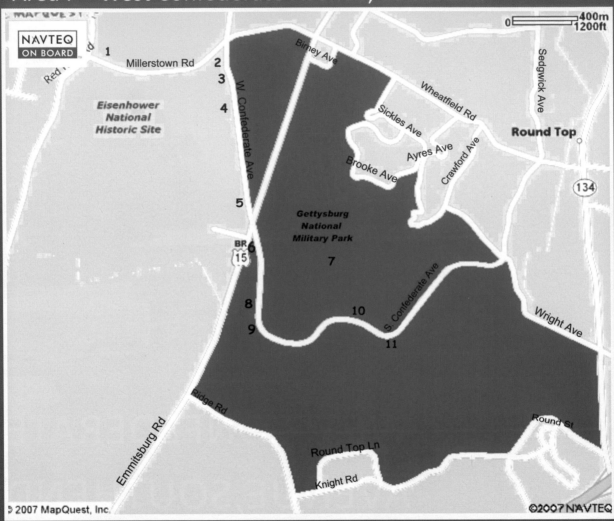

## F-1: Sachs Bridge
**39°47.854'N, 77°16.553'W**

Although this scenic bridge is not directly on the battlefield, it was used by some troops of Longstreet's First Corps in their withdrawal from the battle. Located about a mile from the approximate location of Longstreet's headquarters, it is a nice side trip that takes only a few minutes from the battlefield. Known as Sauck's Bridge at the time of the battle, it has been officially recognized as Pennsylvania's most historic covered bridge. Confederate deserters are said to have been hanged from its rafters. The fields around the bridge served as open-air hospitals during the battle, and several unmarked graves are believed to be in the vicinity. The bridge is a favorite spot for ghost hunters. Those searching for unexplained happenings can be seen here on most summer evenings.

## F-2: Longstreet's Headquarters
**39°48.000'N, 77°15.384'W**

This upturned cannon marks the general area where General James Longstreet set up his headquarters on July 2. The exact location is not known, but it is believed to have been on a small farm just west of the marker, on the Millerstown Road. The farm, owned at the time by the Flaherty family, is now part of the Eisenhower National Historic Site. Longstreet himself gave little clue to the precise location, saying that his headquarters "was in the saddle."

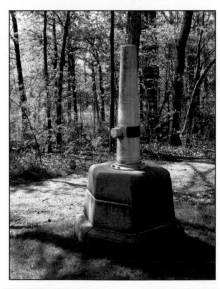

## F-3: Georgia State Memorial
**39°47.932'N, 77°15.359'W**

Georgia's tribute to its native sons who fought at Gettysburg has a twin monument at Antietam honoring the state's casualties at that battle. Both were constructed as part of the centennial celebration of the Civil War in 1961. The simple, yet poignant, inscription states,

> We Sleep Here in Obedience to Law
> When Duty Called, We Came
> When Country Called, We Died

The memorial sits near the site occupied by General Paul Semmes's Georgia brigade.

Of the 13,082 Georgia troops in the fray, 3,855 became casualties over the three days.

## F-4: South Carolina State Memorial
**39°47.870'N, 77°15.355'W**

The South Carolina State Memorial honors the state's eleven infantry regiments, two cavalry regiments, and five artillery batteries that fought at Gettysburg. Each is named on the side panels. Altogether, the state furnished 4,929 troops to the Confederate cause at Gettysburg, more than 1,300 of whom became casualties. The outline of the state is prominent in the center portion of the memorial, with palmetto trees, the state symbol, on either end. It sits where General J. B. Kershaw's brigade formed for the July 2 advance on the Round Tops.

Along the base of the monument is the

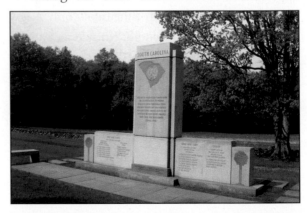

following inscription: "There is no holier spot of ground than where defeated valor lies, by mourning beauty crowned." Those words were penned by South Carolina native Henry Timrod, often referred to as "the Poet Laureate of the Confederacy."

## F-5: Arkansas State Memorial
**39°47.557'N, 77°15.306'W**

Only one regiment from Arkansas fought at Gettysburg. The Third Arkansas Infantry, part of Jerome Robertson's "Texas Brigade," formed at this location. An outline of the state appears in the center of the memorial. Advancing infantrymen are seen on either side of the outline in bas-relief. A unique feature is the aluminum cubes at the front corners of the monument, each containing

a carved Confederate flag. The use of aluminum was meant to symbolize Arkansas' contribution to the nation's economy as an aluminum producer.

The Third Arkansas, heavily involved in the fighting for Devil's Den on July 2, represented the state well. Of the 479 Arkansas troops at Gettysburg, 182, or 38 percent, were either killed, wounded, or missing.

## F-6: Texas State Memorial
**39°47.407'N, 77°15.260'W**

The First, Fourth, and Fifth Texas infantry regiments all fought in John Bell Hood's Texas Brigade at Gettysburg, referred to following Hood's departure as "Robertson's Texas Brigade," after

Brigadier General Jerome Robertson. Part of one of the best units in the Army of Northern Virginia, most of these men fought at Devil's Den and the Rose Farm, although some also fought at Little Round Top. All three regiments took heavy casualties.

During the Civil War centennial, Texas representatives noticed that only two small monuments recognized the Texas Brigade. One was at the Wilderness, the other at Gettysburg. That Gettysburg monument, erected by private citizens, is not the one shown here. The monument in the photo on page 91 resulted from a Texas state project to place similar memorials, relatively simple in design, at each of eleven battlefields. Those memorials to the Texans can be found at Antietam, the Wilderness, Chickamauga, Bentonville, Kennesaw Mountain, Mansfield, Fort Donelson, Pea Ridge, Shiloh, and Anthony, Texas.

One-third of the 1,250 Texans at Gettysburg became casualties.

## F-7: Bushman Farm
**39°47.375'N, 77°15.232'W**

The Bushman Farm lies at the base of Big Round Top, visible in the upper right of the photo above. It stood directly in the path of Major General John Bell Hood's men as they advanced

toward Devil's Den on the second day of fighting. Hood was badly wounded in the farm's Peach Orchard, struck in the arm by an artillery shell. As they crossed the farm, the men of Brigadier General Jerome Robertson's Texas Brigade, in particular, came under heavy artillery fire from Devil's Den, as well as deadly fire from Union sharpshooters in the Bushman farmhouse.

The Union's Twelfth Corps established a hospital at the Bushman Farm that, like most field hospitals at Gettysburg, treated wounded from both sides. That hospital is believed to have received the bodies of Brigadier General Stephen Weed (see photo I-18) and Colonel Patrick O'Rorke of the 140th New York (see photo I-17). Both men are said to have been temporarily buried behind the farmhouse.

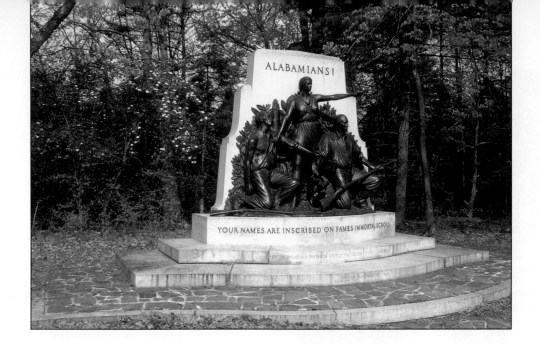

## F-8: Alabama State Memorial
**39°47.193'N, 77°15.256'W**

On the second day of the battle, Alabama regiments under Brigadier General Evander Law stepped out from this location to attack Devil's Den and the Round Tops. Three figures dominate the memorial. The first and most prominent is a female representing the state of Alabama. With her right hand, she comforts a wounded soldier, representing the spirit of the state. With her left, she points the direction she wants the other soldier, representing determination, to go. The wounded soldier can be seen passing his ammunition to the soldier who is advancing. The base of the monument contains an inscription honoring Alabama's native sons who fought at Gettysburg: "Your names are inscribed on Fame's immortal scroll."

Over the three days of fighting at Gettysburg, Alabama saw 2,251 of her sons fall, of 5,928 engaged.

## F-9: Soldiers and Sailors of the Confederacy Monument
**39°47.098'N, 77°15.243'W**

This monument resulted from a movement during the Civil War centennial in 1961 to erect a single memorial that would honor all who

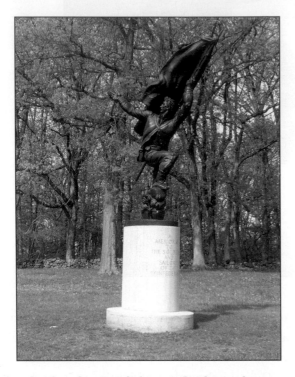

Controversy surrounds his selection, however, as some believe that John B. Salling of the Twenty-fifth Virginia Infantry actually was the final Confederate veteran to die, also in 1959.

## F-10: South Cavalry Field (Site of Farnsworth's Charge)
**39°47.133′N, 77°14.793′W**

By late afternoon on July 3, the fighting at Gettysburg was virtually over. Pickett's Charge had failed. Stuart's assault on the East Cavalry Field had been repulsed. At the location pictured on page 95 just south of the Bushman Farm, Brigadier General Elon J. Farnsworth's brigade waited on the Union's left flank. The brigade consisted of the Eighteenth Pennsylvania Cavalry, the First West Virginia Cavalry, and the First Vermont Cavalry. Behind them sat Battery E of the Fourth United States Artillery, guarded by the Fifth New York Cavalry. Farnsworth was soon joined by Brigadier General Judson Kilpatrick, who had acquired the nickname "Kill-Cavalry" for his many ill-fated cavalry charges.

Kilpatrick ordered a somewhat disorganized attack on entrenched Confederate troops under Brigadier General Evander Law. The attack was repulsed by hand-to-hand combat, at which time Kilpatrick ordered Farnsworth to launch his own

fought for the Confederacy, both in the army and the navy. Gettysburg was chosen as the site. The figure is a Confederate color bearer charging into battle. He is turned slightly, motioning his comrades to follow.

The names of the eleven states that formed the Confederacy and the three border states that sent troops to fight for the South appear on the base. At the rear of the base is the name of Walter Washington Williams. Williams was not the sculptor. Rather, he was said to be the last Confederate veteran to die, passing on in 1959 at the age of 117 years, one month, and five days.

cavalry charge. Farnsworth immediately realized the futility of such an attack. The Southern troops were hidden behind a stone fence with wooden rails piled high on top, preventing horses from jumping over. Farnsworth knew that his men would have to dismount and tear the fence down, all while under heavy fire. He argued against the charge but was overruled by Kilpatrick, who bragged that cavalry possessed the ability to fight "anywhere but at sea." The young general reportedly agreed to lead the charge under protest.

The men rode directly into the setting sun behind the John Slyder farm. The suicidal charge was driven back with great loss of life. Farnsworth was among those killed.

## F-11: Major William Wells Monument
**39°47.088'N, 77°14.716'W**

When Brigadier General Elon Farnsworth led the ill-fated cavalry charge ordered by Brigadier General Judson Kilpatrick, four companies of the First Vermont Cavalry participated. Commanded by Major William Wells, the men from Vermont suffered high losses, as did every regiment in the charge. Wells somehow survived and was awarded the Medal of Honor for his gallantry, having led his men through murderous fire to a position of safety.

Wells had enlisted as a private and advanced quickly through the ranks, receiving more

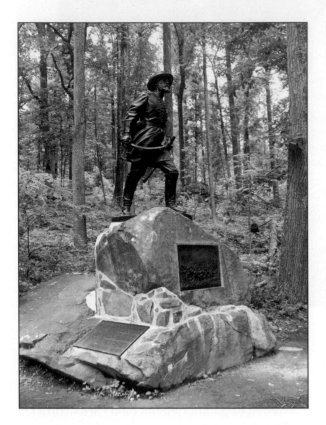

promotions than any other Vermont officer during the war. He eventually became a brevet major general.

A duplicate of this memorial sits in Burlington, Vermont. Although the monument depicts Wells, it honors all those from Vermont who participated in the charge. A detailed plaque on the front of the rock shows the First Vermont during the charge, led by Farnsworth. As models for his work, sculptor J. Otto Schweizer reportedly used photos of each man whose face is visible.

Chapter 7
Area G

HIGH WATER MARK

# Area G   High Water Mark

## G-1: First Minnesota Monument
**39°48.396'N, 77°14.102'W**

On the evening of July 2, 1863, the Confederates were about to overrun the remaining Union troops and capture Cemetery Ridge. Union officers were in the process of desperately assembling artillery units to provide cover for their retreating regiments when General Winfield Scott Hancock ordered the men of the First Minnesota to mount a suicidal charge to buy some time. Eight companies rushed into the breach, just in front of the monument's location, where they encountered several Alabama regiments under Brigadier General Cadmus Wilcox.

Of the 262 men who began the charge, 215, or a full 82 percent, became casualties. Hancock said, "There is no more gallant deed recorded in history." Another 17 Minnesotans would fall the next day in the act of repelling Pickett's Charge. No Union regiment suffered a greater percentage loss during the entire war.

The soldier on top of the monument is shown racing into battle, facing the direction of the actual charge on the second day of fighting.

## G-2: Pennsylvania State Memorial
**39°48.459'N, 77°14.110'W**

Given that the Battle of Gettysburg was fought on Pennsylvania soil, an effort was begun to create one large memorial, independent of all other regimental markers, to honor every Pennsylvanian who fought here. The plan was to dedicate it on the fiftieth anniversary of the battle.

The chosen design was this massive granite memorial, consisting of a dome supported by four archways, each flanked by columns. A twenty-

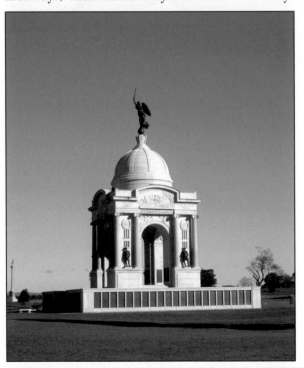

nine-foot-tall "Goddess of Victory and Peace" adorns the top of the dome. The figure was cast of bronze from melted cannons actually used in the war. She holds a sword in her right hand and a palm leaf of peace in her left, symbolizing Pennsylvania's wish that wars should cease and peace should reign on earth.

Above each archway are monoliths easily

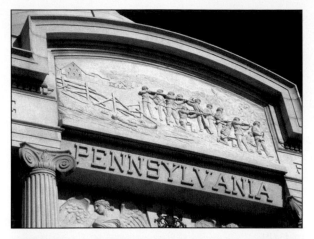

Lincoln, the statues recognize prominent Pennsylvanians: Governor Andrew Curtin, General George Meade (shown adjacent to Lincoln), First Corps commander John Reynolds, Second Corps commander Winfield Scott Hancock, Major General David Birney, Brigadier General Augustus Pleasonton, and Brigadier General David Gregg, a cavalry division commander.

Around the perimeter of the monument are ninety bronze tablets containing the names of Pennsylvanians who fought at Gettysburg. The logistics of gathering all the names proved daunting, and many mistakes were made. Those mistakes are still being dealt with today, nearly 150 years later.

The cost of the monument exceeded $180,000, a princely sum in 1910 when it was dedicated. This made the Pennsylvania State Memorial the most expensive on the battlefield.

## G-3: Fifteenth and Fiftieth New York Engineers Monument
**39°48.484'N, 77°13.996'W**

A turreted castle, the symbol of the Corps of Engineers, was chosen as the design for the monument to the Fifteenth and Fiftieth New York Engineers. It contains brief histories of the two regiments, as well as replicas of an engineer officer's button. The plaque in the top center

missed by those who do not take the time to look up. The monolith shown in the photo re-creates the infantry fighting around McPherson's barn on the first day. Others honor the signal corps, the artillery, and the cavalry.

Eight portrait statues adorn the four corners of the monument. Except for that of Abraham

areas. The locations where each regular regiment fought are marked with identical bronze tablets showing their histories.

Many years after the war, a movement began to further recognize the United States Regulars. The tall obelisk below is the result. Ironically, it is positioned where none of the regular regiments fought. Bronze plaques on the monument list each regiment that fought at Gettysburg, along with the names of their commanders. President William Howard Taft dedicated the monument in 1909.

of the castle depicts a set of pontoon bridges constructed over a river, one of the engineers' main duties. Engineers also built roads, drew maps, and helped design defense works.

The Fifteenth and Fiftieth were the only two engineer regiments from New York to participate at Gettysburg.

## G-4: United States Regulars Monument
**39°48.673'N, 77°14.146'W**

The United States Regular Army, or the regular standing army, was quite small at the outset of the war. Most of the Union army consisted of volunteer regiments. The United States Regulars, however, were an important part of the fighting at Gettysburg, most of their effort concentrated in the Wheatfield and Devil's Den

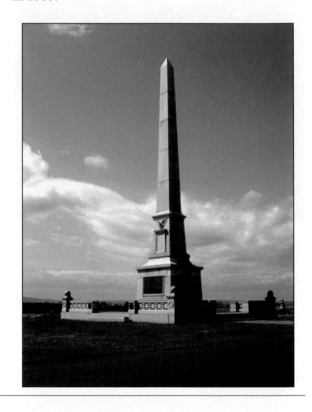

## G-5: Codori Farm
**39°48.680'N, 77°14.414'W**

This farm was owned by Nicholas Codori at the time of the battle. On the second day, Brigadier General Andrew A. Humphreys's Second Division of the Third Corps occupied the extreme right of Major General Daniel Sickles's line, which stretched to this point. Two regiments under Brigadier General John Gibbon took up positions here after Humphreys came under attack. Although the fighting was fierce, the Southern troops were eventually pushed back.

The next day, the fields around the Codori house and barn were filled with troops from both sides. Skirmishing continued throughout the day. When Pickett's Charge began, General George Pickett proceeded to the farm, from which he is believed to have supervised his division in the attack. The assault crossed much of Codori's land on July 3, 1863, Pickett's division passing on either side of the house as it moved toward the Union line.

Interestingly, Codori's brother George was one of nine Gettysburg citizens taken captive by Jubal Early when he had passed through the area a month earlier. George was wearing Union soldier's trousers at the time, which may explain his capture. He spent time in Southern prisons and, tragically, died just three days after returning home.

## G-6: Brigadier General John Gibbon Monument
**39°48.661'N, 77°14.124'W**

General John Gibbon was not honored by a statue in the years immediately following the war. Although he was one of five Pennsylvania generals whose statue funding was approved by the state, the amount set aside proved insufficient, and plans for Gibbon's monument were scrapped.

In the mid-1980s, a group of Civil War enthusiasts in the Philadelphia area took on the project of honoring Gibbon on the Gettysburg battlefield. A monument based on written accounts of Gibbon's appearance was constructed and placed a short distance from where he was wounded. The base is from an old Military Order of the Loyal

Legion of the United States (MOLLUS) monument that had sat in the Mount Moriah Cemetery in Philadelphia. When that monument was vandalized, the granite base was left sitting for years until MOLLUS heard of the Gibbon statue project and offered the stones. As the stones were removed for sandblasting, a small compartment containing an old book was discovered. The book was reconditioned and found to contain the names of the residents of the Old Soldiers Home in Philadelphia. Returned to its compartment, it remains in the base of the monument today.

The monument was dedicated on the 125th anniversary of the battle, July 3, 1988.

## G-7: Peter Fry (or Frey) Farm
**39°48.650'N, 77°13.872'W**

Peter Fry's farm, shown below at dawn, was on the backside of Cemetery Ridge and thus attracted a great deal of artillery fire in the barrage that preceded Pickett's Charge. Much of the Confederate fire overshot its mark, landing on the Fry property and causing extensive damage. During the fighting, troops held in reserve used the farm for concealment.

The farm's location made it an ideal site for a field hospital. More than three hundred wounded soldiers received treatment here. Numerous dead were also removed to the farm, including Colonel George Willard of the 125th New York, who was killed while commanding a brigade made up of the Thirty-ninth, 111th, 125th, and 126th New York infantries. His body was carried to the Fry farmhouse, where it was kept until it could be returned to his home for burial. The orchard

was used as a burial ground for soldiers of both sides.

The farm was later purchased by Basil Biggs. Thus, readers may hear Peter Fry's farm referred to as "the Basil Biggs farm." They are one and the same.

## G-8: Tammany Regiment (Forty-second New York Infantry) Monument
**39°48.720'N, 77°14.124'W**

In the early stages of the war, the Tammany Society, a powerful wing of the Democratic Party, began recruiting a new regiment, to be known as the Forty-second New York Infantry. At Gettysburg, the Forty-second New York fought near the High Water Mark. Its monument sits in the approximate location the regiment occupied during the battle.

This has proven to be one of the more controversial monuments on the field. It features a large teepee, in front of which stands Chief Tamenend, a leader in the Delaware tribe known for his bravery and diplomatic skills. Chosen primarily because the members of the Tammany Regiment were known as "braves," the theme was controversial from the beginning. Critics argued that the monument gave the false impression that Native American tribes participated in the

battle. The teepee's scale also received its share of criticism, many observers stating that it could be used only if its occupant were standing up, its diameter being so small that no normal-sized person could sit or lie down inside.

## G-9: First Pennsylvania Cavalry Memorial
**39°48.771'N, 77°14.122'W**

The First Pennsylvania Cavalry—also known as the Fifteenth Pennsylvania Reserves and the Forty-fourth Pennsylvania Volunteers—stood in reserve during Pickett's Charge at this location on the crest of Cemetery Ridge. Its troops were not pressed into action that day, but the pose of

the soldier on the memorial reflects their state of readiness and determination. Dismounted, this trooper holds his Sharps carbine in position to fire, should the Southern advance break through the Union line.

Private Joseph Lindemuth of the regiment's Company L posed for the sculpture.

## G-10: General Alexander Webb Memorial
**39°48.777'N, 77°14.122'W**

Brigadier General Alexander Webb commanded the Union's Philadelphia Brigade, which defended the line at the Angle. It was Webb who gave permission to Lieutenant Alonzo Cushing to move his remaining guns to the Angle, a move that culminated in Cushing's death (see photo G-16).

Since Webb had been given his command only three days prior to the Battle of Gettysburg, he felt the need to gain the respect of his men as quickly as possible. When the Confederate artillery bombardment began in preparation for Pickett's Charge, Webb calmly puffed a cigar as he leaned on his sword at the front of the defensive line. He refused to move to a more protected position, impressing his troops with his bravery and inspiring them to do no less.

A crisis developed for Webb as Pickett's Virginians forced their way toward the Union position. Part of the Seventy-first Pennsylvania bolted, leaving a gap in the Union's defense. When Webb ordered the Seventy-second Pennsylvania to bridge the gap, it was slow to react. He attempted to grab the regimental flag and move to the front but was unsuccessful, so he rushed forward alone without the flag, receiving wounds in

his thigh and groin in the process. Two New York regiments rushed to fill the gap, and the Confederate attack was ultimately repulsed. Webb personally engaged in the fighting with his Sixty-ninth Pennsylvania.

Webb was awarded the Medal of Honor for his gallantry at Gettysburg. Following the war, he returned to his alma mater, West Point, as an instructor. He later became president of the City College of New York, a position he held for thirty-three years.

## G-11: High Water Mark Memorial
**39°48.747'N, 77°14.143'W**

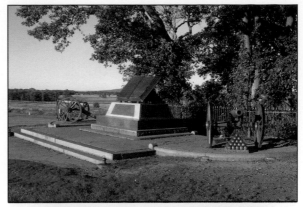

John Bachelder, recognized as the first historian of the battlefield at Gettysburg, is believed to have bestowed the name "High Water Mark of the Rebellion" to note the Confederacy's farthest advance of the war. Never again would the South have such an opportunity to achieve victory. The phrase "High Water Mark" is usually associated with the copse (see photo G-12) that became the focal point of Pickett's Charge. Those trees form the backdrop for the High Water Mark Memorial.

The monument pictured above shows a large open book listing the commands of both armies that were part of Pickett's Charge. The High Water Mark is one of the most visited points on

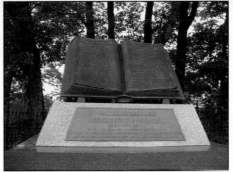

the battlefield and was the scene of numerous veterans' reunions. Former soldiers from both sides often arranged to meet at the stone wall, where they reached across to shake hands.

## G-12: Copse of Trees
**39°48.747'N, 77°14.143'W**

This small copse was the goal of the Confederate army on the afternoon of July 3. The trees themselves bore no significance. During Pickett's

## G-13: Seventy-second Pennsylvania Volunteers Monument

**39°48.779'N, 77°14.176'W**

Charge, they simply served as a directional guide for the Confederates, particularly those in Brigadier General James Kemper's brigade, as they worked their way from Seminary Ridge to Cemetery Ridge through the thick smoke from the guns of both sides. Kemper's right flank came closest to the copse. Many of his men were able to breach the stone wall at that location. However, many more fell to the thunderous fire of the Union guns.

Fighting in this area became hand to hand. But without reinforcements, the Confederates were forced to withdraw, retracing their steps through the very field they had fought so valiantly to cross just a short time before. The copse became better known as "the High Water Mark of the Rebellion" (see photos G-11).

Another controversial monument at Gettysburg is that of the Seventy-second Pennsylvania Infantry. It is the only monument on the battlefield whose location became part of a lawsuit.

Monument placement was the responsibility of the Gettysburg Battlefield Memorial Association, in cooperation with the various veterans' associations that existed at the time. The established and agreed-upon rule was that monuments had to be placed where the regiments were positioned in line of battle. The Seventy-second's position was a short distance back from the current monument's location, along what is now Hancock Avenue.

As the Confederates breached the wall, the

The monument depicts a member of the Philadelphia Fire Zouaves using his weapon as a club, to symbolize the close nature of the fighting in this area.

More than 85 percent of the men in the Seventy-second were under the age of twenty-one, making it one of the youngest regiments in the battle on either side.

## G-14: General Lewis Armistead Monument
**39°48.784′N, 77°14.155′W**

Not far from the marker honoring Lieutenant Alonzo Cushing (see photo G-16) sits a similar marker showing the location where General

Seventy-second was called upon by General Alexander Webb (see photo G-10) to move forward to repel the assault. After the war, the regiment's survivors insisted their monument be placed at that position. When they were refused, they filed a lawsuit, then purchased ground from the Codori family on the Confederate side of the wall, where they threatened to place their monument if they lost the case. The Pennsylvania Supreme Court eventually ruled in the regiment's favor, and the monument was placed at its present location, thus avoiding the awkward situation of having a Union monument on the Confederate side of the line. This led to a great deal of bitterness toward the Seventy-second by other regiments that thought they should have their monuments at the wall as well.

Lewis Armistead was mortally wounded during Pickett's Charge.

As the Confederates reached the stone wall at the Angle, Armistead placed his hat on the tip of his sword and raised it high, yelling, "Give 'em the cold steel, boys!" He climbed over the wall and rushed toward one of Cushing's guns, where he received his mortal wound.

The monument was erected and dedicated in 1887 by friends of the Armistead family. As the first monument on the battlefield to honor a Confederate officer, it was controversial. So was its placement. Armistead was actually wounded about ten feet inside the wall, rather than at the location where the monument was placed.

When Armistead received his wound, he shouted, "My mother is a widow!" Fellow Masons on both sides recognized his cry as a secret distress signal used by the organization. Several Confederate Masons rushed to his side. As he lay wounded, he asked that his regards be passed along to Winfield Scott Hancock (see photos C-11), a Union general and prewar friend. Ironically, Hancock was wounded within minutes of when Armistead fell.

Armistead was taken to the Union's Eleventh Corps Field Hospital at the George Spangler farm, where he died on July 5.

## G-15: View toward Confederate Attack during Pickett's Charge
**39°48.800'N, 77°14.131'W**

Pickett's Charge began with an artillery barrage the likes of which had never before been seen or heard on this continent. So loud that it was audible more than a hundred miles away, it preceded the infantry's advance across these fields. When the artillery stopped its bombardment, Colonel E. Porter Alexander, who was directing the Confederate fire, told Major General George Pickett that he should move quickly, if he planned to attack at all. Pickett in turn asked Lieutenant General James Longstreet if he should advance. Longstreet, who opposed the assault, could not bring himself to give the order. Instead, he simply nodded his head slightly.

The Confederate infantry stepped out into what must have seemed like a suicide mission. Nearly a mile of open field had to be traversed under heavy fire. Surprisingly, some actually made it safely across, only to be driven back.

The view on page 110, looking toward the Codori Farm, is what much of the Union army saw on the afternoon of July 3.

## G-16: Cushing's Battery and Monument
**39°48.790'N, 77°14.145'W**

The commander of the Fourth United States Artillery at Gettysburg was Lieutenant Alonzo Cushing, a twenty-two-year-old who had graduated from West Point just two years before the battle. Cushing's battery, positioned at this approximate location near the Angle, received concentrated

fire in the bombardment that preceded Pickett's Charge. When the artillery fire died down, Cushing saw that most of his guns were destroyed and that only a few gunners had not been killed. Cushing himself had received painful wounds but was unwilling to leave the field. He received permission to move his two remaining guns to the wall, where he directed fire at the advancing Confederates and served as one of the gunners.

Struck in the mouth by a bullet, Cushing died instantly, his body tumbling over the gun trail. He was buried at West Point. This marker was placed in 1887 by his family and friends.

## G-17: California Monument
**39°48.802'N, 77°14.179'W**

This unusual monument is marked as that of the Seventy-first Pennsylvania Infantry but is also referred to as "the California Monument." How was it that a Pennsylvania regiment was given such a designation?

Early in the war, a regiment was to be credited to the state of California. Senator Edward Baker of Oregon received the task of organizing the regiment. Recruiting took place in New York and Philadelphia. It didn't take long to form a regiment, designated as the First California Infantry. Eventually, four more regiments were organized for California, the recruiting taking

## G-18: The Angle
**39°48.806'N, 77°14.184'W**

place in Pennsylvania.

Baker was killed at Ball's Bluff, at which time the state of Pennsylvania claimed four of the five California regiments, applying them to the Keystone State's quota and giving them their new designations. The Second California became the Sixty-ninth Pennsylvania, the Third California became the Seventy-second Pennsylvania, and the Fifth California became the 106th Pennsylvania. These regiments were grouped together. Since most of the troops were recruited in Philadelphia and their officers were Philadelphians, it became "the Philadelphia Brigade," the only brigade in either army to carry the name of a city.

The Fourth California Regiment was comprised of artillery and cavalry. Its troops were detached from the other four California regiments.

The Angle was named for the stone wall that formed a ninety-degree bend at this location. Union troops were positioned along the wall during Pickett's Charge. The Angle saw some of the most brutal action of the entire battle. When

the fighting was over, a survivor said that the bodies lay so close together that it was difficult to walk through the area without stepping on them.

After the war, the Angle became a meeting place for veterans of both sides during reunions. They would stand on their respective sides of the wall and reach across to shake hands with those opposite them, showing unity and respect.

## G-19: Cemetery Ridge Stone Wall
**39°48.822'N, 77°14.142'W**

The small rise in front of the cannons pictured below constituted the final few feet that the Confederate left flank, under Brigadier General James J. Pettigrew and Major General Isaac Trimble, had to traverse. Faced by two brigades of Union soldiers from the Second Corps under General Alexander Hays, the Confederates were decimated. Fifteen Confederate flags were captured and more than 2,500 weapons were recovered in this general area, indicating the carnage. Nearly 1,250 Confederate soldiers were temporarily buried in front of this wall, including an unidentified female who had posed as a man, possibly to fight alongside her husband or sweetheart. Her tragic story will never be fully known.

## G-20: Camp Colt Marker
**39°48.893'N, 77°14.257'W**

This tree and marker are the only formal references on the battlefield to an event outside the Civil War. Although thousands of people drive past them every day, few are aware of their significance.

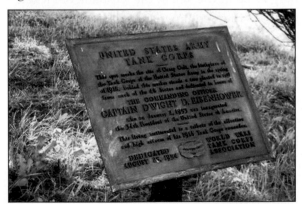

The tree and marker sit alongside Emmitsburg Road at the site of the left flank of Pickett's Charge. They commemorate the general location of Camp Colt, a training ground for the Tank Corps during World War I. A young army captain named Dwight David Eisenhower served as the commander of Camp Colt. Soil from each state was blended together, into which the tree was planted.

The camp was used again during World War II, this time as a temporary prison camp for German POWs.

## G-21: Field of Pickett's Charge, from Union View
**39°48.905'N, 77°14.125'W**

The low stone wall in the foreground below provided shelter for the Union army as the Confederates advanced across the field in front of them on July 3. The field in this view was filled by twelve thousand Confederate soldiers marching into the teeth of heavy fire. When the battle was over, the field was littered with dead and wounded. Fewer than half the Confederates who made the assault returned.

The handful of Confederates who reached the wall engaged in hand-to-hand combat with the Union troops at this location. Decades later, survivors stood on either side of the wall and shook hands with their counterparts on the

other side in a show of remembrance, unity, and friendship.

## G-22: Eleventh Mississippi (University Greys) Monument
**39°48.920'N, 77°14.131'W**

Company A of the Eleventh Mississippi Infantry was made up of students from the University of Mississippi. Their origin gave rise to the nickname "University Greys." When the Eleventh Mississippi stepped out to take part in the assault known as Pickett's Charge, 31 members of the Greys followed. As they approached the wall at the Brian Farm (see photos G-24), they were decimated by Union cannon fire. Eight color bearers of the Eleventh Mississippi fell in the assault. Only 53 of the original 393 officers and

men were unscathed. Every one of the University Greys was either killed or wounded.

This monument marks the spot of the Eleventh Mississippi's, and the Confederacy's, farthest advance.

## G-23: 111th New York Infantry Monument
**39°48.925'N, 77°14.123'W**

The men of the 111th New York served in the battle as skirmishers, meaning they were initially scattered in front of the main Union line to provide advance warning of any assault. The nature of their deployment made it difficult to select a site for their monument. The regiment's monument committee finally decided to place it at the spot the regimental colors stood, where it

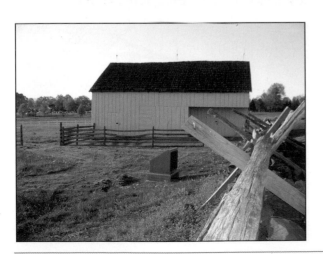

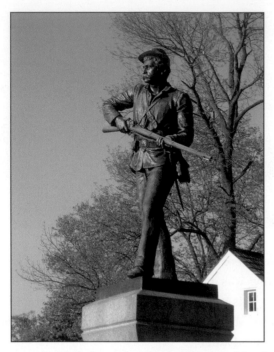

## G-24: Brian Farm
**39°48.928'N, 77°14.110'W**

This farm was owned by a freedman named Abraham Brian, who lived with his wife, Elizabeth, and their five children. The orchard adjoining their small farmhouse was also his. He grew wheat and barley on his twelve acres. The house and barn in these photos are actually reconstructions, the originals having been destroyed by time.

As did most farmers in Gettysburg, the Brians evacuated when it became apparent a battle was imminent. The house became the Union headquarters of Brigadier General Alexander Hays (see photo G-29). When the fighting was over, the Brians returned to find their home in shambles, the farm having been the focus of the left flank of Pickett's Charge, under the command

appears in the photo on page 115. On this site, the 111th lost four color bearers and two officers during Pickett's Charge. Overall, the battle cost the lives of ninety-five men of the 111th.

The very nature of being skirmishers meant that the men were subject to attracting enemy fire at any time. The monument reflects that, as the young soldier stands with his weapon at the ready, finger on the trigger. It is not out of line to think of skirmishers as the equivalent of a canary in a coal mine. They were usually the first to come into contact with the enemy, often drawing fire before they could make it safely back to their lines.

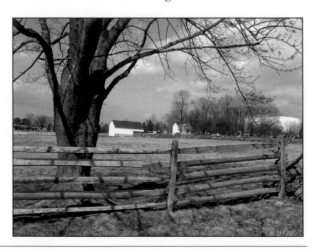

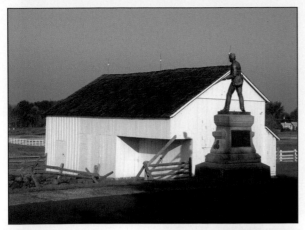

ernment complied. His compensation? A total of fifteen dollars.

## G-25: General George Gordon Meade Monument
**39°48.831'N, 77°14.088'W**

Major General George Gordon Meade was placed in command of the Army of the Potomac just two days before the Battle of Gettysburg. His comment upon assuming command was, "I have been tried and condemned." Meade was not President Lincoln's first choice for the position, Major General John Reynolds (see photos A-3, A-10, and C-5) having earlier refused the command.

Meade's monument sits on Cemetery Ridge. Depicted bareheaded as he was on July 3, he appears to be riding up to the brow of the hill from his headquarters (see photo G-26) to check

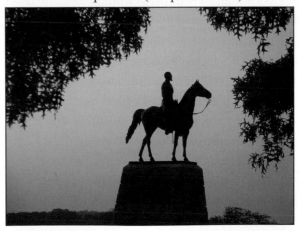

of Brigadier General James J. Pettigrew and Major General Isaac Trimble. The windows had been smashed out, the fences destroyed, the crops trampled, and the orchard ruined. The area west of the barn was now a graveyard.

Abraham Brian tried to rebuild his farm and his life, eventually requesting government reimbursement for his property damages. The gov-

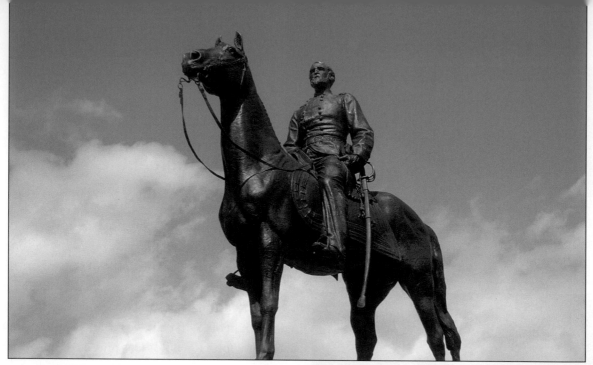

the battle's progress firsthand. His gaze is fixed on his opponent on Seminary Ridge, General Robert E. Lee (see photos E-6), whose likeness peers similarly back at his Union counterpart.

Although new to his command, Meade used his subordinates skillfully, depending on their abilities and their familiarity with the troops under their respective commands. He also is credited with excellent troop placement throughout the battle, predicting Lee's final assault and assuming a strong defensive position. His quick and decisive action is generally recognized as the key factor in the outcome of the battle.

The general was severely criticized by Lincoln for failing to attack Lee as he retreated to Virginia. Meade's reasoning that his men had taken a severe beating and needed a day of rest was not well received by the president.

## G-26: Lydia Leister House (Meade's Headquarters)
**39°48.866'N, 77°13.942'W**

This small house along the Taneytown Road became the headquarters of General George Meade during the battle. Owned by widow Lydia Leister, the headquarters had to be abandoned temporarily during the bombardment that preceded Pickett's Charge, since shells that overshot the Union position were striking dangerously close.

This was the scene of Meade's famed council of war on the evening of the second day of fighting. Meade summoned his corps commanders to the two-room house to discuss the progress of the battle and to decide their plan for the next day. The main question was, should the Union army defend the position it currently held, or should it go on the attack? The decision to remain in position and defend was nearly unanimous. The backup plan was to attack only if Lee refused to do so.

As with most homes in the days following the fighting, the Leister House became a hospital for both Union and Confederate wounded.

## G-27: Ninth Massachusetts Battery
**39°48.956'N, 77°14.096'W**

The Ninth Massachusetts Battery was active in the fight for the Wheatfield, inflicting heavy damage on the Confederate army in the area of the Rose Farm. Eventually forced back to a new position at the Trostle Farm, the battery was ordered to hold its position at all costs, and did

so until overrun. In that action, it lost three of its four officers, six of its seven sergeants, and twenty-eight of its sixty enlisted men. In addition, eighty of its eighty-eight horses were either killed or disabled. Bugler Charles Reed was awarded the Medal of Honor for his actions in saving the wounded battery commander, Captain John Bigelow.

What little remained of the battery (two guns, one officer, and a handful of enlisted men) moved to Ziegler's Grove on July 3, just in time to participate in Pickett's Charge. The photo on the right on page 119 shows the unit's position and the view the men had of the assault that day.

## G-28: GAR Memorial
**39°48.967'N, 77°14.089'W**

Following the war, the Grand Army of the Republic (GAR) was formed as an organization of Union veterans. Its purpose was similar to that of the modern-day American Legion and Veterans of Foreign Wars: to provide support for veterans and promote a social atmosphere. The GAR sponsored several reunions, including some in Gettysburg.

This monument to the organization depicts a veteran gazing across the fields of Pickett's Charge. Ironically, the model, Albert Woolson of Minnesota, did not fight at Gettysburg. Although

truly a veteran, Woolson had been too young to join the army when the war began. He was finally accepted into the First Minnesota Heavy Artillery as the fighting reached its final stages. Woolson was the last surviving member of the GAR. When he died in 1956 at the age of 109, the GAR died with him.

This monument honoring the more than two million Union fighting men was placed by the Sons of Union Veterans of the Civil War, the successor to the Grand Army of the Republic.

## G-29: General Alexander Hays Monument
**39°49.009'N, 77°14.072'W**

General Alexander Hays commanded the Third Division of the Second Corps at Gettysburg.

His men were positioned along the northern fringe of Cemetery Ridge in an area known as Ziegler's Grove. Hays set up his headquarters at the Brian Farm (see photos G-24).

During Pickett's Charge, Hays and his men faced Southern troops under Brigadier General James J. Pettigrew and Major General Isaac Trimble. The two armies slugged it out, inflicting heavy casualties on one another, until the Confederate line was repulsed. Hays encouraged his men throughout the battle, moving from place to place and shouting orders. His division captured fifteen Confederate flags, one of which Hays dragged through the dust on horseback as the Confederates retreated. His men cheered his action.

Hays was killed less than a year later at the Battle of the Wilderness. He was brevetted a major general posthumously, to date from his death.

## G-30: Maryland State Memorial
**39°48.975'N, 77°13.946'W**

Following the theme that the Civil War was truly a conflict of brother versus brother, Maryland's monument honors all troops from that state who fought at Gettysburg, whether Union or Confederate. Considering Maryland's status as a border state, that appears fitting. Six Union and five Confederate units made up of three thousand men from Maryland fought at Gettysburg and are named on the monument.

The monument depicts a soldier assisting a

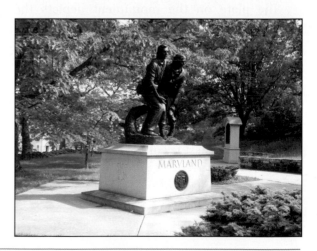

wounded comrade. No designation is made as to which side is represented, which is as it should be. Such scenes took place in both armies.

The monument was dedicated in 1995 and is one of the newest on the field.

## G-31: Delaware State Memorial
**39°48.966'N, 77°13.949'W**

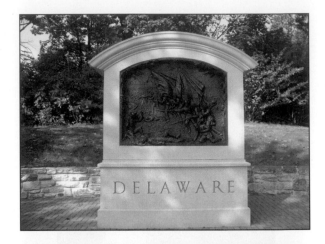

Delaware was represented by the First and Second infantry regiments, which served with distinction on the second and third days. Both regiments are honored by this state memorial. Positioned in Ziegler's Grove, the Delaware troops assisted in the repulse of Pickett's Charge, losing nearly a quarter of their number. Three of the men from Delaware were awarded the Medal of Honor for their actions at Gettysburg.

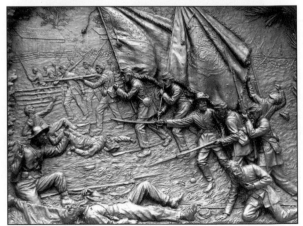

The plate on the monument depicts the First and Second Delaware in a countercharge against the left flank of Pickett's Charge. It is representative of many scenes on the various monuments on the battlefield, most of them works of art in their own right. The meticulous attention to detail is often missed by visitors who fail to examine all sides of the monuments.

Chapter 8
Area H

THE WHEATFIELD

# Area H   The Wheatfield

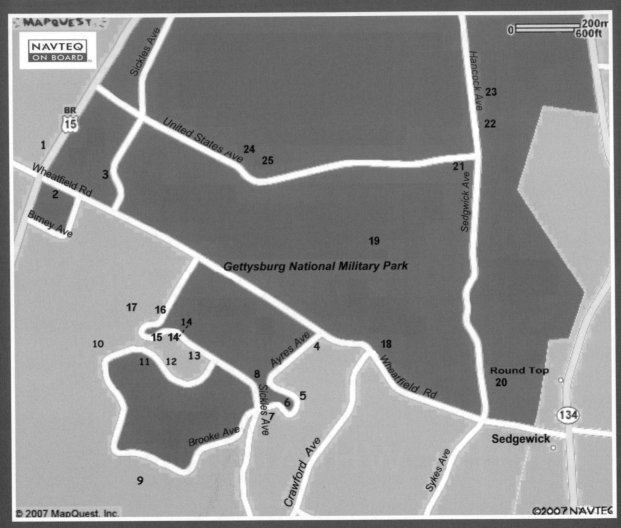

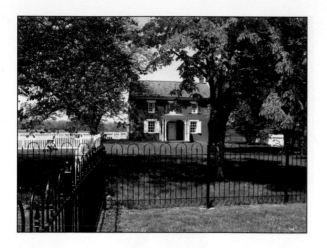

## H-1: Sherfy House
**39°48.209'N, 77°14.926'W**

The home of the Reverend Joseph Sherfy figured prominently in the second day of fighting. The battle raged on all sides of the house and in the orchard, which produced enough peaches to allow the Sherfy family to conduct a canning business. On the evening of July 2, 1863, General William Barksdale's Confederate brigade smashed through the Union line at this location and advanced through Sherfy's Peach Orchard and into the valley in front of Cemetery Ridge.

The house was riddled with bullets during the fighting. The scars can still be seen. In addition to the heavy damage to the house and its contents, the Peach Orchard, which was much larger than it is today, was also badly mangled. Limbs were torn from the trees. In many cases, entire trees were uprooted or shattered by artillery fire. At some point, a shell ignited the barn, which burned to the ground. Inside were dozens of wounded soldiers, many of whom were unable to get out.

After the battle, Sherfy salvaged what he could, then showed a stroke of marketing genius by advertising his peaches as coming from the original trees on the Gettysburg battlefield.

## H-2: Hampton's Battery F Monument
**39°48.080'N, 77°14.966'W**

Captain Robert Hampton's Battery F of the Independent Pennsylvania Light Artillery had

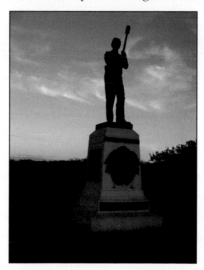

suffered so many casualties that it actually fought as part of Captain James Thompson's Battery C at Gettysburg. The monument depicts a young artilleryman holding a rammer, one end of which was used to insert the artillery shell, the other to sponge water into the gun to extinguish any remaining sparks that might prematurely ignite the next shell. It sits at the approximate location in the Peach Orchard where the battery fought on July 2, 1863, until overrun by the advancing Confederates.

In recognition of an act of bravery, one of many on both sides, Private Casper Carlisle was awarded the Medal of Honor after retrieving one of the battery's cannons that had been captured by the Confederate army.

Battery F of the Independent Pennsylvania Light Artillery had seven men killed at Gettysburg.

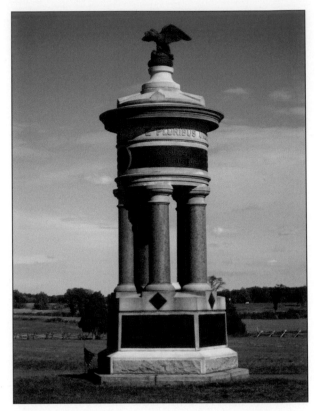

## H-3: Excelsior Brigade Monument
**39°48.107'N, 77°14.849'W**

This unique five-sided monument honors the five regiments of the Excelsior Brigade: the Seventieth, Seventy-first, Seventy-second, Seventy-third, and Seventy-fourth New York infantries. The regiments were all raised by Daniel Sickles, a former congressman serving as temporary colonel of the Seventieth New York. Sickles, a womanizer who left a trail of unpaid bills in his wake, was infamous for killing his wife's lover, Philip Barton Key, son of Francis Scott Key. Sickles eventually finagled a political appointment to the rank of brigadier general.

The monument sits at a position central to the locations of the five regiments during the fighting on July 2. Although each of the regiments could have erected its own memorial, they had been organized together and fought together, and their committees decided they should also be honored together.

In one of history's great ironies, the open space visible on the interior of the monument was originally meant to house a bust of Sickles. The bust had to be omitted when an audit of the New York Battlefield Monuments Commission discovered nearly thirty thousand dollars was missing. It was soon learned that the funds had been taken by none other than Sickles himself, thus depriving him of the recognition he believed he deserved.

## H-4: Eleventh Pennsylvania Reserves Monument
**39°47.819'N, 77°14.405'W**

The Eleventh Pennsylvania Reserves were also known as the Fortieth Pennsylvania Infantry. When President Lincoln called for volunteers, Pennsylvanians answered in huge numbers, quickly filling their allotments. Rather than

turn valuable manpower away, officials put the extra men into reserve units. When more troops were needed, they were sworn into Federal service and given regimental names. Those official designations generally were twenty-nine regiments higher than the reserve designations. That is, the Eleventh Reserves became the Fortieth Infantry by adding twenty-nine to the original designation, since twenty-eight regiments had been sworn in already. Other examples of Pennsylvania reserve unit name changes include the Second Reserves, which became the Thirty-first Pennsylvania Volunteer Infantry, the Third Reserves, which became the Thirty-second Pennsylvania Volunteer Infantry, etc.

The Eleventh Reserves, armed with only smoothbore muskets, arrived on July 2 and were quickly placed into service. Using buckshot, they led a charge across the field, where they were to stop at a stone wall. Many of the men, however, crossed the wall and were able to capture a number of prisoners.

## H-5: Little Round Top, Seen from the Valley of Death
**39°47.699'N, 77°14.443'W**

A small stream known as Plum Run meanders through the low area between Devil's Den and Little Round Top, seen in the background of the

photo on page 128. During the battle, this area was littered with the dead of both armies, and Plum Run ran red with their blood. For more than a week after the fighting, the bodies remained unburied in the hot July sun, the stench adding to the misery of those who remained behind.

The nickname "Valley of Death" was given to the area after the battle and is still commonly used today. As more and more visitors came to view the scene, a group of enterprising businessmen saw an opportunity and created the Gettysburg Electric Railway, which transported tourists through the Valley of Death and around Devil's Den and Little Round Top, where a small amusement park was built. After many protested what they viewed as exploitation of the dead, the amusement park was closed in 1896. The controversial trolley, however, continued to operate until it was finally removed around 1915. Portions of its rail bed can still be seen.

## H-6: Bucktails Monument
**39°47.714'N, 77°14.481'W**

This is the regimental monument for the Thirteenth Pennsylvania Reserves, also known as the Forty-second Pennsylvania Volunteer Infantry. They were best known, however, as "the Pennsylvania Bucktails" for the trademark buck tail each man wore on his cap. To get into the regiment, a soldier had to prove his marksmanship, and the buck tail he wore had to be from a buck he had shot himself.

As the courage of the Bucktails grew legendary, two more Bucktail regiments were organized under the orders of Secretary of War Edwin Stanton, to form the Bucktail Brigade.

The original Bucktails resented the two new regiments, the 149th and 150th Pennsylvania Volunteers, referring to them as "Bogus Bucktails." The original Bucktails even went so far as to file a protest with the Pennsylvania Monument Commission, on the grounds that they were the only regiment authorized to wear buck tails or place a buck tail on their monument. Their argument was ignored.

Though not shown in the photograph on page 128, the buck tail on the soldier's kepi is clearly visible in this monument to the original Bucktails. The word *Bucktails* is engraved on the base.

## H-7: Fifth New Hampshire Monument
**39°47.702'N, 77°14.513'W**

This unusual monument commemorates not

only the Fifth New Hampshire but also its former commander, Colonel Edward E. Cross, who was killed on this spot. The boulders around the base and on the top were gathered from various locations around the battlefield, while the granite block in the center is from New Hampshire.

Cross, who had already been wounded nine times in the Civil War, plus three additional times in earlier service, had a premonition he would be killed that day, July 2. When Major General Winfield Scott Hancock told him, "Colonel Cross, this day will bring you a star [a promotion to brigadier general]," Cross replied, "No, General, this will be my last battle." Some fifty yards from where the monument now stands, a Confederate soldier took aim as Cross approached with his troops. The shot struck Cross in the midsection, and he died later that night. The boulder from which the fatal shot was fired can still be seen near the intersection of Ayres and Sickles avenues.

The monument also contains the names of thirty others who fell that day in the battle for the Wheatfield.

## H-8: The Wheatfield
**39°47.776'N, 77°14.602'W**

The area of the battlefield known as "the Wheatfield" actually consists of three distinct parts: the twenty-five-acre field of wheat owned

by George Rose, plus the Rose Woods and Stony Hill, to the west; Houck's Ridge, to the east; and Devil's Den, also to the east. The Wheatfield sits at the approximate geographic center of Longstreet's second-day assault.

Nineteen brigades totaling more than twenty thousand men engaged in a series of attacks and counterattacks over a period of several hours, producing nearly seven thousand casualties and giving rise to a nickname, "the Bloody Wheatfield." During the battle, troops found themselves moving back and forth across the same ground several times. This unusual ebb and flow caused the Wheatfield to change hands at least six times—and also made it one of the least understood parts of the battlefield.

The fight for the Wheatfield began when Georgia troops under Brigadier General George T. Anderson and Arkansas troops under Brigadier General Jerome B. Robertson moved into the Rose Woods on July 2, where they initially encountered the Twentieth Indiana, the Seventeenth Maine, the 115th Pennsylvania, and the Eighth New Jersey. Additional troops from both sides soon joined the fray, and it wasn't long before the two armies were engaged in hand-to-hand combat.

When the fighting ended, neither side could claim control of the area. Rose's wheat had been trampled into the ground, and his fields were littered with dead and wounded. Streams ran red with blood. By nightfall, wild hogs moved into the area and began feeding on the bodies.

## H-9: Timbers Farm
**39°47.563'N, 77°14.861'W**

The photo above is an example of how interesting features of the battlefield can be missed if visitors stay only on the traditional tourist paths. At first glance, these rocks do not appear to be anything out of the ordinary. However, a closer examination reveals a rectangular pattern. They are all that remains of the foundation of the Timbers Farm, located here during the fighting. The site sits in the woods about 150 yards from the main road and can be found with only a little effort.

At the time of the battle, the house here was occupied by the George Weikert family. George himself was away fighting in Cole's Cavalry. Anderson's Brigade passed through the front yard on its way to the Wheatfield. Fighting took place in the area immediately surrounding the house.

Later, John Timbers, a free black, occupied the home and gave it its current name. Timbers eventually hanged himself here, although many historians suspect he was actually the victim of a lynching.

## H-10: Rose Farm
**39°47.784'N, 77°14.868'W**

This 236-acre farm was owned by George W. Rose on July 2, 1863, although the family fled by the time the fighting began. Much of the battle for the Wheatfield took place on Rose's property, when South Carolina troops under General Joseph B. Kershaw, aided by reinforcements from Georgia under Brigadier General Paul Semmes, fought a seesaw struggle with a Union brigade

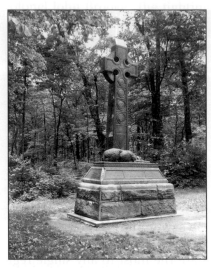

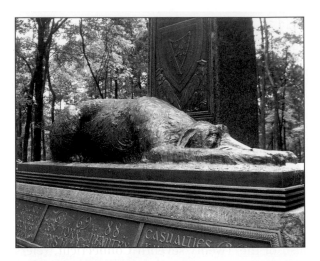

regiments, the state of New York, and Ireland. The Massachusetts and Pennsylvania regiments have monuments of their own elsewhere on the battlefield. Perhaps the most outstanding feature of this memorial is the Irish wolfhound reposing at the base. It represents faith and devotion.

Interestingly, the monument also includes a plaque on the side of the base honoring the Fourteenth New York Independent Battery. This artillery unit was part of the original Irish Brigade when it was mustered in. Although it was later detached, it also fought at Gettysburg. When the veterans decided on the design of their memorial, they chose to include their former comrades.

By the time the battle took place, the Irish Brigade had suffered so many casualties that only 530 men were available, making it the smallest Union brigade at Gettysburg. Of those

troops, 198 became casualties in the wooded area surrounding the monument.

## H-14: Thirty-second Massachusetts Monument and Plaque
**39°47.819'N, 77°14.758'W (monument) and**
**39°47.832'N, 77°14.695'W (hospital site)**

This pup tent, pictured on page 135, is the regimental monument designed by S. C. Spaulding, a veteran who served with the Thirty-second Massachusetts. It is located on the spot where the Thirty-second formed a firing line in the fight for the Wheatfield. The monument was dedicated in 1894. Its cost: the grand sum of five hundred dollars.

Those from the Thirty-second Massachusetts

who were unfortunate enough to find themselves casualties received better, or at least quicker, treatment than most. The reason was that regimental surgeon Z. Boylston Adams saw the need for a temporary hospital where the wounded could receive treatment before being transported to one of the larger field hospitals. That temporary hospital was set up behind the boulders shown in the photo below. The

temporary hospital established by Adams was credited with saving many lives, as indicated by the bronze plaque placed on the boulder.

## H-15: Second Andrews Sharpshooters Monument
### 39°47.822'N, 77°14.775'W

A small detachment of Berdan's Sharpshooters was named for John A. Andrews, the Massachusetts governor. Its original position was in front of the main Union line, where its men used their unique marksmanship skills to slow the Confederate advance through the Wheatfield.

This lifelike monument (pictured on page 136) is unusual because it does not have a traditional base, the sharpshooter appearing to be taking cover behind a large rock. The rock and

the sharpshooter were carved from a single block of granite.

The monument was vandalized several years ago. When most visitors hear this, they assume the rifle barrel was broken off. In truth, the block of granite from which the monument was carved was not large enough to include a rifle barrel. The vandalism is easily visible in the closeup, the line around the throat indicating where the head was removed.

## H-16: 116th Pennsylvania Volunteers Monument
**39°47.850'N, 77°14.752'W**

The 116th Pennsylvania suffered a sizable number of casualties prior to Gettysburg and took many more in the battle for the Wheatfield. Because of the high casualty rate, the survivors of the 116th Pennsylvania chose to depict their regiment's suffering, rather than the courage portrayed on most of the battlefield's monuments.

Major St. Clair Mulholland, commander of the 116th Pennsylvania, was said to have seen a soldier who had recently died in the fighting.

A faint smile could be seen on the young man's face. That smile haunted Mulholland. In the monument, a dead soldier lies near the wall where he fought, his hand still gripping his musket. The battle's destruction is represented by the shattered fence, the damaged musket, and the broken bayonet scabbard. At Mulholland's suggestion, the scene he witnessed was re-created in this regimental memorial.

## H-17: First Michigan and 118th Pennsylvania Flank Marker
**39°47.849'N, 77°14.801'W**

Nearly every regimental monument at Gettysburg has flank markers, small stones saying *LF* (left flank) and *RF* (right flank), indicating the extreme ends of the regimental line. This marker is unusual because it denotes the right flank of

the First Michigan and the left flank of the 118th Pennsylvania. Although other regiments butted up against one another all over the battlefield, this is the only place at Gettysburg where two regiments share a marker.

## H-18: Ninety-sixth Pennsylvania Volunteers Monument
**39°47.767'N, 77°14.263'W**

This highly detailed monument is unique in that it honors a regiment that actually saw no fighting at Gettysburg. Held in reserve, the Ninety-sixth Pennsylvania Infantry maintained a defensive position that is reflected in this memorial. The intensity on the young soldier's face and his thumb on the hammer of his weapon emphasize the readiness and determination of the men who fought on both sides. Interesting

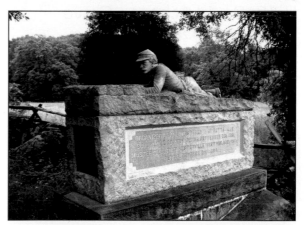

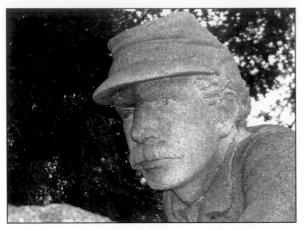

details on the monument include the corps insignia on the soldier's kepi and a footprint next to his foot.

The Ninety-sixth Pennsylvania remained at this location from July 2 to July 5, when it participated in the pursuit of the Confederate army as it returned south.

## H-19: David Acheson Grave
**39°47.900'N, 77°14.283'W**

Rock carvings on the battlefield are far more numerous than most visitors realize. This is one of the most interesting, more for its history than for its content.

Captain David Acheson of the 140th Pennsylvania Volunteers was killed in the Wheatfield (see photo H-8) in action against South Carolina regiments under Brigadier General Joseph Ker-

shaw. Because of the intensity of the fighting, his men could not search for his body immediately. On July 4, the day after fighting ceased, Acheson's body was located and field-buried at this location. Someone carved his initials into a boulder that sat at the head of his grave, as a means of locating his remains later. Relatives arrived quickly to recover his body. On July 13, his remains were disinterred and taken home to Washington, Pennsylvania, for reburial. At some point over the next few years, someone added the "140 P.V." to identify Acheson's regiment.

This grave site may be difficult to locate, but a small flag is usually placed at the boulder to aid in the search. The boulder sits just inside the tree line on the west side (the Little Round Top side) of the George Weikert farm (see photo H-21), just off the Wheatfield Road.

## H-20: General John Sedgwick Monument

**39°47.772'N, 77°14.031'W**

Known to his men as "Uncle John," Major General John Sedgwick commanded the Sixth Corps of the Army of the Potomac at Gettysburg, although the corps was kept in reserve for the most part. Various parts of the Sixth Corps were assigned to other corps as needed throughout the battle, leaving Sedgwick with little to do and causing him to snarl, "I might as well go home."

Although Sedgwick had little impact on the outcome at Gettysburg, the people of his home state of Connecticut chose to honor his overall service with this monument.

Sedgwick's death came in dramatic fashion in May 1864 near Spotsylvania. As he positioned his troops, Confederate sharpshooters began finding their range. When his men dodged the bullets, Sedgwick chided them, saying, "They couldn't hit an elephant at this distance." Shortly afterward, a sharpshooter proved Sedgwick wrong as his bullet found its mark, striking the general just under his left eye and killing him instantly.

## H-21: George Weikert Farm

**39°48.127'N, 77°14.072'W**

On July 2, Brigadier General John C. Caldwell's division of Major General Winfield Scott Hancock's Second Corps rushed past the Weikert House on its way to the Wheatfield. The farm itself saw significant fighting, some of it in the Weikerts' yard.

On the third day of the battle, Federal artillery under Lieutenant Colonel Freeman McGilvery formed a line of guns that stretched from around

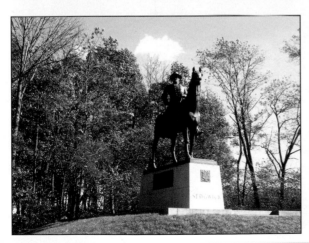

the Weikert House to the area now occupied by the Pennsylvania Monument. Those guns were instrumental in repelling the Confederate advance during Pickett's Charge.

The Weikert Farm served as a field hospital during and after the battle. Hastily dug graves dotted the property for some time afterward.

## H-22: Father Corby Monument
**39°48.205'N, 77°14.063'W**

This monument honors the hundreds of chaplains present on the field in 1863. As chaplain of the Eighty-eighth New York Infantry of the famed Irish Brigade, Father William Corby,

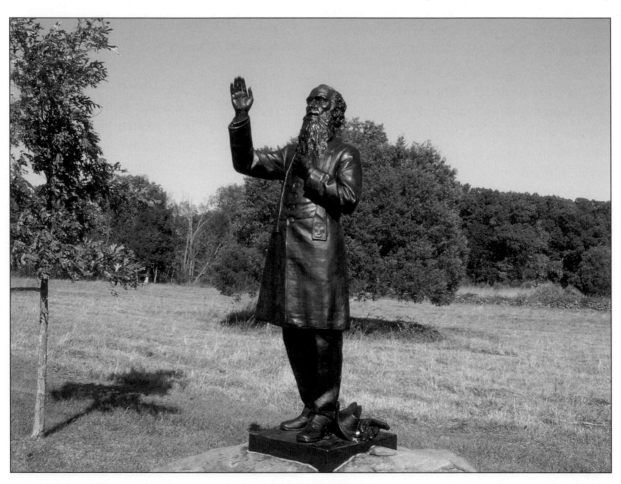

twenty-nine years old, has become as famous as many of those who actually bore arms those three fateful days. As the Irish Brigade formed up to enter the fight, Father Corby stepped onto a boulder—some historians believe the very boulder on which the monument stands—and raised his hand. Three hundred soldiers drew silent, many of them dropping to their knees, as the battle raged around them. The priest blessed them, prayed for their safety, and granted a general absolution, after which the troops marched into the fight. Corby's admonition that the church would refuse a Christian burial for any man who failed to do his duty that day rang in their ears as they headed off.

Following the war, Father Corby became president of the University of Notre Dame. A replica of this monument stands on the university's campus, marking his grave. Years after the war, veterans of the Irish Brigade petitioned to have the Medal of Honor awarded to Corby, a request that was ultimately denied.

## H-23: New York Auxiliary Monument
**39°48.256'N, 77°14.063'W**

Officially the New York Auxiliary Monument, this memorial is often referred to facetiously as "the Monument to Every New Yorker Who Doesn't Have a Monument Somewhere Else."

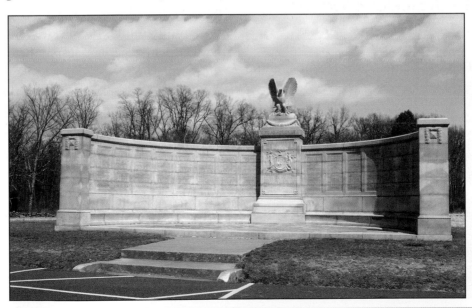

That tongue-in-cheek description is not far off, as the New York Battlefield Monuments Commission chose to establish a single memorial to honor every New Yorker from the rank of major to general who commanded a unit at Gettysburg. The end result is this impressive structure containing the names of forty-one officers from New York. The monument is forty-two feet wide and twenty-four feet deep and has a large eagle at its center. The names are inscribed on eighteen panels.

Although the monument was not dedicated until 1925, sixty-two years after the battle, nearly a hundred Civil War veterans were able to attend.

## H-24: Site of Sickles's Wounding
**39°48.152'N, 77°14.566'W**

Major General Daniel Sickles, commanding

the Third Corps, was placed on the southern end of Cemetery Ridge on the second day of fighting. As befit his reputation for doing things on his own terms, he believed that a more favorable location for his artillery would be about a half-mile forward, and he moved his troops into that area, contrary to orders. Stretched from Devil's Den to the Peach Orchard, then along the Emmitsburg Road, his flanks were exposed and created a gap in the Union line.

Sickles's Third Corps was overwhelmed and nearly decimated by brigades from Mississippi and Georgia under Generals William Barksdale and William Wofford. Driven back to the Trostle Farm, Sickles had his right leg shattered by a cannonball at this location in front of the Trostle barn. Perhaps because it is often thought to be on private ground, the Sickles Monument does not get many visitors, despite being so close to the parking area.

As Sickles was carried from the field, he is said to have stopped the stretcher bearers until he could casually light a cigar, providing inspiration to his troops. After his leg was amputated, he had it preserved and sent to the Army Medical Museum in Washington, where he visited it often following the war. Years later as a congressman, Sickles introduced legislation that established the Gettysburg National Military Park.

# H-25: Trostle Farm
**39°48.102'N, 77°14.553'W**

The Abraham Trostle farm was one of the largest in the Gettysburg area at the time of the battle. It was also one of the most prosperous, containing a large, new house, a barn, a wagon shed, an extensive apple orchard, and numerous fertile fields. The fighting destroyed most of that.

After the family left the farm when it became apparent that fighting was imminent, Major General Daniel Sickles set up his headquarters in the front yard. On July 2, advancing Confeder-

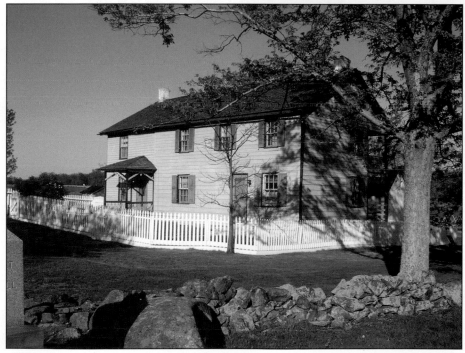

ates threw the Union army into disarray. Artillery shells rained onto the farm, wounding Sickles (see photo H-24). As the Union artillery retreated, the Twenty-first Mississippi rushed onto the farm and captured five guns of the Ninth Massachusetts Battery. The Twenty-first Mississippi continued until it reached Plum Run, where it stopped to rest and reorganize. That delay allowed time for Union reinforcements to arrive and push the Mississippians back. In the fighting, Confederate general William Barksdale was mortally wounded.

The Trostle barn still shows signs of the fighting. A hole remains visible just above the lower roofline where an artillery shell pierced the brickwork. Visitors to the farm shortly after the battle reported dozens of dead horses lying in the yard.

The house and outbuildings were used as a field hospital during and after the fighting. The family reported that its crops and many personal items were stolen or destroyed. The Trostles never received any compensation for the damages.

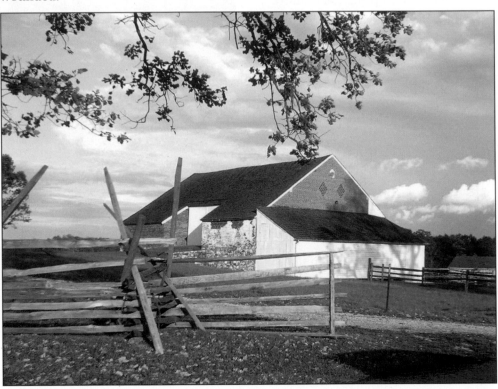

Chapter 9
Area I

# LITTLE ROUND TOP,

# DEVIL'S DEN

# Area I    Little Round Top, Devil's Den

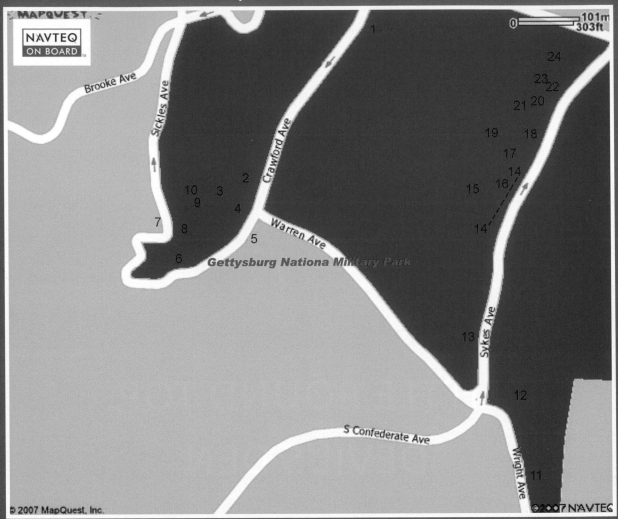

## I-1: Brigadier General Samuel Wylie Crawford Monument
**39°47.756'N, 77°14.327'W**

When the fighting in the Wheatfield moved toward Little Round Top, the Third Division of the Fifth Corps was called on to take a stand and stop the advancing Confederates. The Union launched a counterattack, Brigadier General Samuel Wylie Crawford joining in. Crawford commandeered the flag of the First Pennsylvania Reserves, which had become stuck in a tree. With the color bearer following closely, Crawford completed the charge. His monument shows him holding the bullet-riddled flag.

After the war, General Crawford was concerned that the area where his men fought would not be preserved adequately. He personally purchased forty-seven acres around this monument to ensure that it would be protected. The acreage included the Valley of Death and Devil's Den. When the Gettysburg National Park Commission expressed interest in acquiring the property, promising to preserve it forever, Crawford agreed to sell it back.

The roadway running past his monument is named Crawford Avenue in his honor. It is shown here as dawn begins to break.

## I-2: Houck's Ridge
**39°47.604'N, 77°14.444'W**

As the fighting in the Wheatfield and Devil's Den intensified, the Confederate army began to overrun the ranks of Union troops. Desperately trying to reorganize, the Northerners rushed across this open area. The view in the photo on page 148 is toward the Wheatfield; Devil's Den is

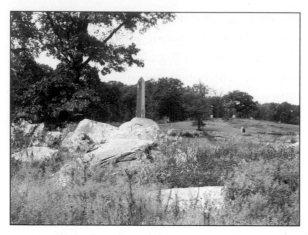

to the left of the photo. The obelisk in the center marks the position of the Sixth New Jersey, which was charged with covering the retreat of several regiments from Hobart Ward's brigade. A small stream at the base of this hill, Plum Run, soon ran red with the blood of troops from both sides. The bullets showed no preference, the valley soon earning its new name: "the Valley of Death."

## I-3: Little Round Top from Devil's Den
**39°48.526'N, 77°14.546'W**

Once the Confederates captured Devil's Den, they had an unobstructed view of Little Round Top, seen in the distance. Sharpshooters hidden by the massive boulders waited patiently for Union troops on Little Round Top to carelessly show themselves. Following the battle, the slopes

of Little Round Top were covered with dead and wounded. Cries for water resounded throughout the night of July 2 as both sides waited for dawn before resuming the fight.

At the time of the battle, Little Round Top had no official name. It was most often considered an extension of Round Top, or Round Top Mountain. Those names referred to what is known as Big

Round Top today. Edward Everett used the name Little Round Top in his speech at the dedication of the national cemetery. The name became popular. Little Round Top is one of the most recognized battle sites in America today.

## I-4: Devil's Den
**39°47.488'N, 77°14.515'W**

Most visitors to Gettysburg eventually find their way to Devil's Den, another of the highly

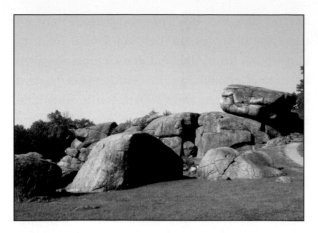

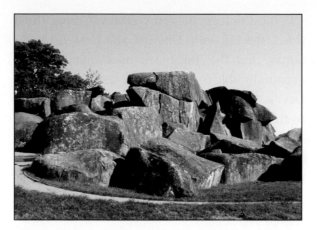

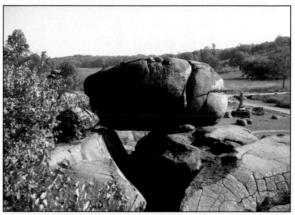

visited spots on the battlefield. Earlier names given to this outcropping of boulders were "the Big Rocks" and "Devil's Cave," but Devil's Den was used by most locals at the time of the fighting and is the name used nearly exclusively today.

Where did it originate? One version says a large snake made its home in the rocks and gave rise to the name. Others refer to the general appearance of the area and the horrors here during the battle. Another popular story says that, while most people assume the name refers to the rocks, Devil's Den was actually a local name for a small cave within the rocks. All that can be said with any certainty is that nobody knows which version is true.

On the afternoon of July 2, 1863, the Union recognized the advantages of positioning artillery among the rocks, which provided protection and offered a vantage point that allowed observation of Confederate movements in the Warfield Ridge area. Four guns of the Fourth New York Battery (see photo I-8) sat here. However, two additional guns could not be brought into the rough terrain and so were placed in the valley to the right and rear. There was also no place to station the limbers for the guns. Since the limbers carried the ammunition, the only way to feed the guns was to carry ammunition up the slope while under fire.

The Confederate army attacked from three sides. The Fifteenth Georgia, the First Texas Infantry, and the Third Arkansas Infantry were eventually able to overrun the Union position at Devil's Den, despite a desperate counterattack by the 124th New York Infantry (the Orange Blossom Regiment). The Confederates captured three artillery pieces. Sharpshooters then positioned themselves where they had a clear line of fire at anyone foolish enough to show himself on Little Round Top.

## I-5: Slaughter Pen
**39°47.478′N, 77°14.520′W**

Located at the base of Big Round Top on the opposite side of the park road from Devil's Den, this collection of boulders has come to be known

as "the Slaughter Pen" for good reason. Here, on the second day of the fighting, Union infantry and troops from Alabama and Georgia engaged in vicious combat as the Southerners pushed their way toward Devil's Den. Battle lines and formations were impossible to maintain in the rock-strewn terrain visible in the photo below, and soon blue mingled with gray. Within minutes, the tangle of boulders became a graveyard for dozens of brave men on both sides.

Following the war, tourists flocked to this location and Devil's Den in such numbers that a local photographer set up a photo gallery at the Slaughter Pen, from which he sold shots of the battlefield and took pictures of visitors posed on the rocks.

## I-6: Confederate Sharpshooter's Nest
**39°47.502′N, 77°14.573′W**

On the upper left on the next page is a famous photo taken immediately following the battle, showing a dead Confederate sharpshooter in a small alcove within Devil's Den. The photo has since been proven to have been staged, the body brought in from somewhere else in the vicinity to lend drama. The photo below it shows the same area as it appears today.

Although the original photo was staged, sharpshooters indeed occupied this area. Early

National Archives photo no. 165-SB-41

unconfirmed stories contend that one of those sharpshooters fired the shot that killed Colonel Strong Vincent (see photos I-14). Although likely, such a claim cannot be proven.

## I-7: Triangular Field
**39°47.556'N, 77°14.586'W**

This small field west of Devil's Den was the scene of bloody fighting on the afternoon of July 2 as troops from Texas, Georgia, and Arkansas stormed across it in their attack on the Union position in Devil's Den. Emerging from the woods at the bottom of the hill, they immediately came under heavy fire from Union artillery. Although they took heavy casualties, they eventually were able to overrun the Union position in Devil's Den (see photo I-4) and capture three guns of the Fourth Battery, New York Light Artillery (see photo I-8).

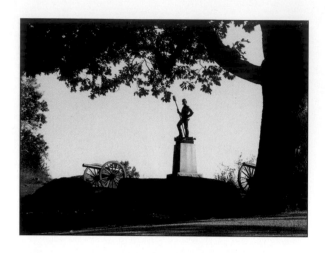

gular Field (see photo I-7) and prepared accordingly. Smith got his wish, but only partially, as the Confederates advanced from the Triangular Field but also from two other sides, creating havoc for his gunners. After several attacks, the Fourth New York Battery was overrun and pushed out of the Devil's Den area.

It is believed that a shell from one of the Fourth New York Battery's guns shattered the arm of Confederate general John Bell Hood.

## I-8: Monument for Fourth Battery, New York Light Artillery
**39°47.523'N, 77°14.551'W**

## I-9: Ninety-ninth Pennsylvania Infantry Monument
**39°47.542'N, 77°14.536'W**

The monument pictured above at the top of Devil's Den may or may not look like this when you see it. Unfortunately, it was a victim of thoughtless vandals in February 2006 and had not been repaired as of this writing. The bronze artilleryman was pulled from the base and dragged 160 feet along the roadway, badly damaging it. Its head was also removed and has not been recovered. The photo shows the monument as it was prior to the destruction.

On July 2, the Fourth New York Battery, as it has come to be known, was positioned at the extreme left of Daniel Sickles's extended Third Corps line. Its captain, James Smith, hoped the attack would come from the west and the Trian-

In the fighting for the Devil's Den area, the Fourth New York Battery (see photo I-8) and its infantry defenders from the Fourth Maine and the 124th New York became the focal point for General Evander Law's brigade. When the intense pressure from Law's men threatened to push the Union troops out of Devil's Den, the Ninety-ninth Pennsylvania, under the command of Major John W. Moore, was called in for reinforcement.

Shouting "For Pennsylvania and our homes!" the men of the Ninety-ninth arrived at the scene and poured a murderous fire on the approaching Second and Seventeenth Georgia regiments. In the charges and countercharges, they were able to temporarily regain control of the battery for

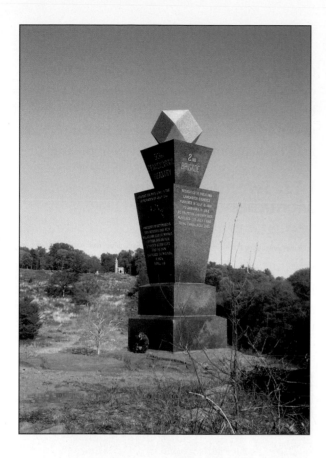

## I-10: Above Devil's Den
**39°47.570'N, 77°14.569'W**

the Union. Despite heavy casualties, however, the Confederates pressed on and eventually succeeded in driving the Union troops, including the Ninety-ninth Pennsylvania, off the rocks.

The Ninety-ninth's color sergeant, Harvey May Munsell, performed heroically that day, his clothing pierced by eleven bullets in the fighting. His coolness and bravery earned him the Medal of Honor.

The rustic scene pictured above is in stark contrast to the carnage that took place throughout the area above Devil's Den on the second day, the bloodiest of the three days of fighting. Confederates under General John Bell Hood swept across this area, driving Union forces ahead of them. The roar of musketry was deafening, the smoke choking. The blood of many on both sides flowed freely.

Today, the scene is one of peaceful beauty. Visitors walk through the area admiring the scenery and taking photos. While the nearby Devil's Den and Little Round Top garner attention, many are oblivious to the horrors that took place on this very spot in 1863.

Vermont Brigade did its part in the war effort, even though it was not actively engaged at Gettysburg. Some 1,172 of its men died of wounds over the course of the war, more than any other brigade in the Union army. The lion atop its monument symbolizes the courage and gallantry that marked its performance throughout the war.

## I-12: Twentieth Maine Monument
**39°47.197'N, 77°14.370'W**

Those familiar with the movie *Gettysburg* will immediately recognize the name of the Twentieth Maine. Its monument sits in the approximate location occupied by the regimental colors.

The Twentieth Maine, under Colonel Joshua

## I-11: First Vermont Brigade Monument
**39°47.099'N, 77°13.943'W**

Paying homage to the Second, Third, Fourth, Fifth, and Sixth Vermont infantries, the First Vermont Brigade Monument is unique in honoring a brigade that did not play an active role in the fighting at Gettysburg, having been held in reserve at this position.

Generally, the Union army did not place a large number of regiments from the same state into one brigade, but General William "Baldy" Smith was able to convince Secretary of War Edwin Stanton to allow all the Vermont regiments to stay together as either the First Vermont Brigade or the Second Vermont Brigade.

Also known as "the Old Brigade," the First

Chamberlain, stood at the extreme left of the Union line on July 2. It had orders to hold its position at all costs. The attacks, primarily by the Fifteenth Alabama Infantry, came in waves, but the Twentieth Maine held its ground. When his men were almost out of ammunition, Chamberlain ordered a bold bayonet charge down the slope of Little Round Top into the valley, thus securing the left flank of the Union line. Many made the charge with empty guns. Thirty-eight were killed in the fighting, and their names are inscribed on the monument. Chamberlain was awarded the Medal of Honor for his actions.

A short distance from the monument sits a small marker commemorating the regiment's Company B, sent out to protect the Twentieth Maine's flank, where it fought with no support.

## I-13: Eighty-third Pennsylvania Monument
**39°47.414'N, 77°14.219'W**

This monument honors the Eighty-third Pennsylvania and its acting brigade commander, Colonel Strong Vincent. It is especially interesting because it represents a blatant act of defiance on the part of the regiment.

The regiment fought on the summit of Little Round Top, where Strong Vincent was killed (see photos I-14). Wishing to honor its commander, the regiment proposed a monument in his memory.

However, the Pennsylvania State Monument Commission, in charge of administering the funds for all the state's Civil War monuments, refused the request. The commission insisted that the monuments were to honor the common soldier and were not to commemorate any individual or specific deed. The regiment's defiance became apparent at the unveiling, however. Although Vincent is not identified on the monument, the statue bears a marked resemblance to the fallen officer.

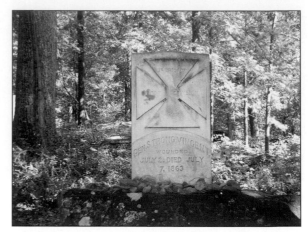

# I-14: Death of Strong Vincent

**39°47.457'N, 77°14.216'W (monument) and**

**39°47.477'N, 77°14.222'W (boulder inscription)**

Two locations on Little Round Top are said to be the site of Strong Vincent's mortal wounding.

On a small path about midway between the Eighty-third Pennsylvania Monument (see photo I-13) and the monument to the Forty-fourth and Twelfth New York regiments (see photo I-16) sits a marker claiming to be on the spot of his wounding. The marker is shown in the two photos above.

The photos below show a boulder immediately adjacent to the Forty-fourth and Twelfth New York Infantry Monument. The inscription

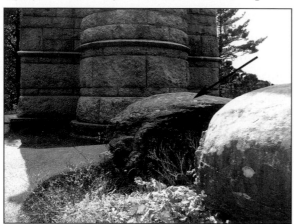

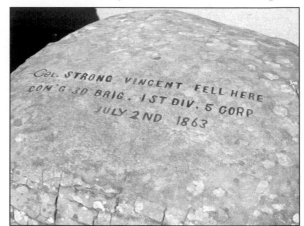

carved on top of the rock, indicated by the arrow, has worn down and is difficult to read, although occasionally someone outlines the letters as shown here. The inscription says,

> Col. Strong Vincent Fell Here
> Com'g 3d Brig. 1st Div. 5 Corp
> July 2nd, 1863

Which is correct? We probably will never know for sure. If timing means anything, the inscription on the boulder appeared several years before the monument was placed. Another clue is the wording. The boulder inscription refers to Colonel Strong Vincent, while the formal marker refers to General Strong Vincent. Vincent was promoted from colonel to general as he lay on his deathbed, which has led some historians to believe the marker was a tribute to that promotion and was not as accurately placed. It is more likely the location to which Vincent was carried following his wounding.

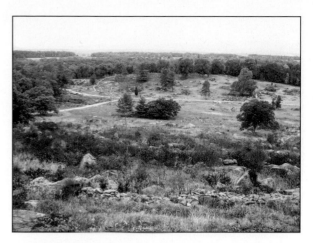

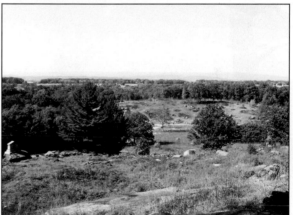

## I-15: Views from Little Round Top
**39°47.462'N, 77°14.240'W**

The views pictured here are all toward the Confederate positions during the second day. The fighting for three areas of the battlefield—Devil's Den, the Wheatfield, and Little Round Top—seemed to converge at the area seen from this vantage point.

As the Confederates advanced from Houck's Ridge, the Union line disintegrated and the troops from a division of United States Regulars under General Romeyn Ayres found themselves the sole defenders of the position. The regulars were quickly swept aside, suffering high casualty

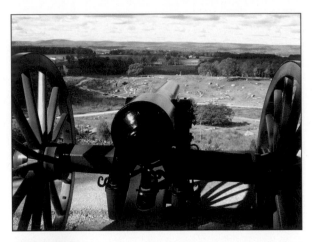

The Battle of Gettysburg raged on for another day. The day after that, July 4, saw a rainstorm. The rain quickly swelled Plum Run and caused it to overflow its banks, drowning a number of wounded soldiers who had not yet been tended to and adding to the terrible slaughter.

Many visitors driving down Crawford Avenue on their way to Devil's Den or Little Round Top don't realize they are passing through one of the bloodiest stretches of the entire battlefield.

## I-16: Forty-fourth and Twelfth New York Infantry Monument
### 39°47.475′N, 77°14.221′W

This impressive structure (photo on page 159) on Little Round Top honors the men of the Forty-fourth New York Infantry and two companies of the Twelfth New York Infantry. The dimensions of the monument, built to look like a castle, are significant. The tower is exactly forty-four feet high, honoring the Forty-fourth New York. The interior chamber is twelve feet square and twelve feet high, honoring the Twelfth New York. A circular staircase inside the structure leads to an observation deck, from which the Valley of Death, Devil's Den, and the front of Little Round Top can easily be viewed. Two tablets inside the chamber honor a pair of former regimental officers: General Dan Butterfield, generally credited as the

rates as they fought in retreat mode back across Plum Run. A counterattack by a brigade of Pennsylvania reserves slammed into Brigadier General William Wofford's Confederates and drove them back toward the Wheatfield, the dead and wounded Southerners adding to the casualty rate in the Valley of Death, the low area at the base of Little Round Top.

composer of the bugle call Taps and the designer of this monument, and General Francis Barlow (see photo A-22), who was badly wounded on the first day of fighting while commanding a division in the Eleventh Corps. Additional bronze plaques inside the chamber contain the muster rolls for each company in the regiment.

Known as Ellsworth's Avengers, in honor of Ephraim Elmer Ellsworth, who was killed in Alexandria, Virginia, by the proprietor of a hotel as he removed a Confederate flag, the Forty-fourth New York fought in the defense of Little Round Top, suffering 106 casualties out of 313 men engaged. Companies D and E of the Twelfth New York fought as part of the Forty-fourth New York and suffered no casualties.

It is believed that the Forty-fourth and the Twelfth were positioned about a hundred feet in front of the site of their monument at the time of the battle.

# I-17: 140th New York (Death of O'Rorke) Monument
**39°47.485'N, 77°14.222'W**

The men of the 140th New York Infantry, wearing their bright Zouave uniforms, stood at this position in the defense of Little Round Top on the second day of fighting. Their commander, Colonel Patrick O'Rorke, had graduated first in his class at West Point and was highly respected by his men. When Alabama troops under General Evander Law attacked, the 140th New York pushed them back and secured the position. In that action, however, O'Rorke was killed by a shot through the neck at this location. When the regiment commissioned its monument, it was the unanimous wish of every man that their fallen colonel be honored.

In observing the monument, one thing that

immediately stands out is the fact that the colonel's nose appears to be brightly polished. Legend says that O'Rorke lost his luck of the Irish the day he was killed but transfers it to anyone rubbing his nose. The thousands of visitors who do so every year maintain its highly polished appearance.

## I-18: Deaths of Weed and Hazlett
**39°47.524'N, 77°14.197'W**

The inscription on this monument on the summit of Little Round Top tells the story:

> Erected by the 91st Regt. P.V.
> In Memory of Brg Gen Weed
> 3 Brig. 2 Div. 5 A.C.
> And Lt. Chs. E. Hazlett,
> 5 U.S. Arty, Who Fell
> On This Spot July 2, 1863

When General Gouverneur Warren (see photos I-20) requested reinforcements, he probably did not have artillery in mind. Such weapons would have been of little use in firing on troops advancing up the hill because they could not be depressed enough to be effective.

As with several men who fought at Gettysburg, Lieutenant Charles E. Hazlett had a premonition of death. Hazlett's battery of six guns was the first to reinforce Little Round Top, despite his misgivings. Although he did not plan to use his guns on troops coming up the hill, they would be useful in firing on Devil's Den and the Wheatfield, Hazlett reasoned.

As the battle for Little Round Top wound down, Brigadier General Stephen Weed was mortally wounded. Lying on the ground, his

blood slowly seeping into the rocky soil, he called for Hazlett and motioned for him to move closer. As Hazlett did so, he was shot in the head and killed instantly, collapsing onto Weed. Weed died shortly after at an aid station.

## I-19: Curious Rocks
**39°47.546'N, 77°14.203'W**

This unusual pile of boulders has had numerous names through the years but is best known as "the Curious Rocks." It has been referred to as "the Natural Fortification" at times and has even been called "Devil's Den" in error. Easily seen on the front of Little Round Top, the rocks probably served as a shield for the Ninety-first Pennsylvania, the 146th New York, or both during the fighting on July 2. Although they appear to be delicately balanced and prone to tipping over,

they are actually quite stable and can be safely approached. Visitors should refrain from climbing on them, however.

## I-20: General Gouverneur Warren Monument
**39°47.551'N, 77°14.198'W**

When General Daniel Sickles moved his Third Corps forward to the Peach Orchard on the afternoon of July 2, he left a gap in the Union line. As a result, Little Round Top was unprotected, occupied by only a handful of signalmen. As the signalmen prepared to leave, General Gouverneur Warren arrived as ordered by General George Meade and quickly noticed a Confederate battle line being drawn up on the ridges beyond the Wheatfield. That line overlapped the unprotected gap in the Union line. Warren ordered the signalmen to remain in position so as to give the appearance that the hill was occupied by Union

The rock on which it stands is believed to be the one from which he observed the Confederate formation.

## I-21: Houck's Ridge from Warren's Position
**39°47.551'N, 77°14.198'W**

The photo below is the approximate view Warren had as he peered toward Houck's Ridge. Looking across the low ground, which had not yet earned the sobriquet "Valley of Death," he observed the ranks of Confederates as they advanced toward his location. From this vantage point, he was able to see the gap in the Union line created by Sickles's ill-fated advance. He knew it was only a matter of time before the Confederates would hold the high ground on which he stood. His decisive action to move Union troops into the area is one of the most understated stories of the battle.

troops. He also sent his aides for reinforcements from the Fifth Corps. His actions prevented Little Round Top from falling into Confederate hands, inspiring his nickname, "the Savior of Little Round Top."

Warren's monument shows him holding his field glasses as if observing the movements of the Southern troops, as at the time of the battle.

## I-22: Signal Rock
**39°47.550'N, 77°14.190'W**

The Union army established several signal stations on the battlefield. This one on Little Round Top was arguably the most strategic because it sat so high and enabled the signalmen to send their messages to nearly every other station on the field. Just as importantly, it enabled them to easily observe most of the Confederate army's movements. Using this knowledge, Union commanders were able to adjust their positions.

When General James Longstreet made his advance on July 2, the signalmen on Signal Rock were visible to him and bothered him a great deal, contributing to the delay in getting the Confederate troops into position to attack the Union's left. Although the signalmen and their officers were able to monitor troop movements,

they also found themselves exposed to artillery fire and sharpshooter fire from Devil's Den. Despite this danger, they remained at their post and were instrumental in keeping General Meade apprised of Confederate activities in the area.

A bronze plaque on Signal Rock was placed by the survivors of the Signal Corps.

## I-23: View from Signal Rock to the Town of Gettysburg
**39°47.550'N, 77°14.190'W**

The Signal Corps had the view, pictured above, looking toward the north, looking past the northern end of the Valley of Death toward the town of Gettysburg. From here, it could observe the entire Union line as it extended in its famous fishhook pattern. This illustrates perfectly the advantage the Confederates would have had if they gained the hill. The high ground would have provided them the same view of the

enemy, making the Union forces vulnerable to enfilading fire along the entire length of the line. The resulting carnage could have changed the outcome of the battle.

The monument in the photo marks the position of the 155th Pennsylvania (see photos I-24).

## I-24: 155th Pennsylvania Infantry Monument
**39°47.576'N, 77°14.191'W**

This life-sized statue of a member of the 155th Pennsylvania Infantry stands on Little Round Top wearing a representation of the colorful uniform of the Zouaves: red pants with white leggings, a dark blue jacket, and a tassled fez. The original Zouaves were Algerian tribesmen whose reputation for bravery in battle led to a number of Zouave units being formed in the Union army.

In truth, the 155th was not a Zouave unit until 1864, so the soldier is not dressed as he would have been at Gettysburg, although there was no intent to deceive. The original monument did not have the soldier on top. He was added three years later, when sufficient funding became available. By then, the 155th had become a Zouave unit and wore the uniform shown on the monument. The model was Private Samuel Hill of the regiment's Company F. He stands in the direction the 155th faced during the battle, as if he never left.

Unfortunately, this monument, like many others, bears the scars of the thoughtlessness of vandals. Although it has been repaired, the soldier's right hand was broken off, and a name has been scratched into the base on the north side. On the lower front of the rock portion, the remains of spray paint are still visible.

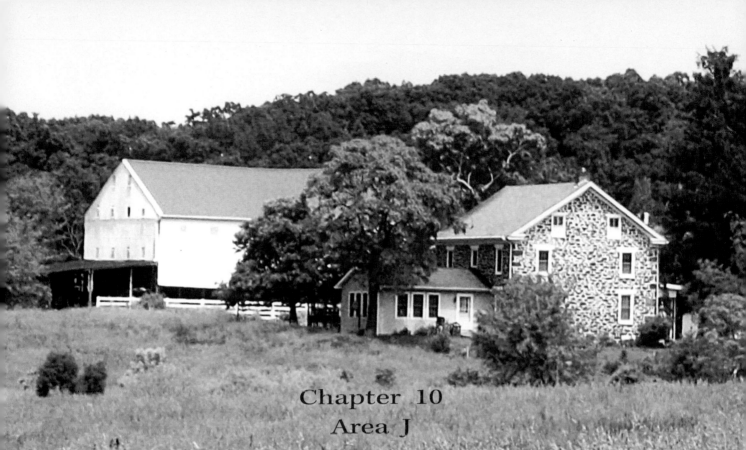

Chapter 10
Area J

EAST CAVALRY
BATTLEFIELD

# Area J   East Cavalry Battlefield

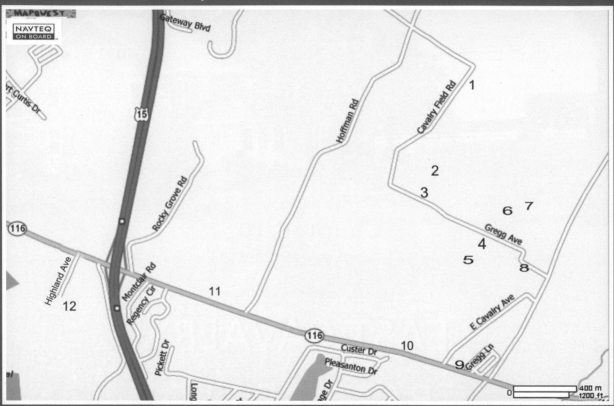

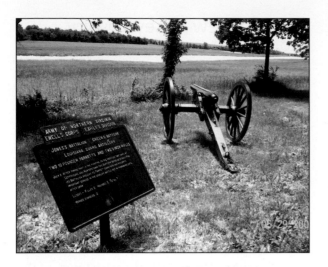

## J-1: East Cavalry Field
**39°50.275'N, 77°10.044'W**

Planning to capitalize on the Union's confusion following what he hoped would be a successful assault (Pickett's Charge), General Robert E. Lee ordered Major General J. E. B. Stuart to protect the Confederate left flank while attacking the Union from the rear. Stuart's route would take him through the intersection of Hanover Road and Low Dutch Road, where Brigadier General David Gregg's division awaited him. Brigadier General George Armstrong Custer's brigade, on loan to Gregg from Brigadier General Judson Kilpatrick's division, was also on hand.

Stuart planned to cross Cress Ridge in the vicinity of the Rummel Farm (see photos J-2) and strike the Union's left flank, but the Union skir-

mishers provided unexpected resistance. This view on the left shows the area of fighting as seen from Stuart's artillery position. Stuart finally ordered an all-out assault that culminated in a cavalry battle here on the Rummel Farm. The scene looks remarkably similar to the way it did at the time of the battle.

## J-2: Rummel Farm
**39°49.727'N, 77°10.211'W**

The area around the John Rummel farm became part of the Battle of Gettysburg when Major General J. E. B. Stuart attempted to move his cavalry to a position to attack the Federal rear as a follow-up to Pickett's Charge. He was intercepted by the Union cavalry. Stuart's men arrived at Gettysburg in an exhausted state on the

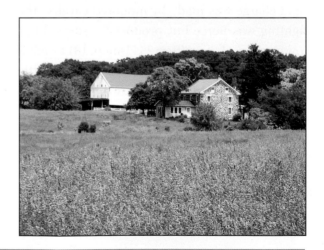

## J-3: First New Jersey Cavalry Monument
**39°49.723'N, 77°10.199'W**

As the Confederates advanced toward the Rummel barn, Colonel John B. McIntosh, commander of the First Brigade, ordered the First New Jersey Cavalry to dismount and proceed to a small fence row. There, it encountered a dismounted force of Confederate troops positioned in and around the barn. Soon, the air was filled with bullets and smoke as each side tried to force the other back. With the assistance of the Fifth and Sixth Michigan cavalries, Union forces pushed the Southern troops back. The monument below sits where the First New Jersey was positioned.

evening of the second day's fighting, following a circuitous ride around the right flank of the Army of the Potomac. Until the third day, they played no role in the fighting.

Much of the action in this area took place with the troopers dismounted, although Stuart's final charge was made by mounted cavalry. The fighting was fierce but produced a surprisingly low number of casualties: 254 Union, 181 Confederate. When the assault was repulsed, the battle became a strategic loss for the Confederacy, and the Union rear remained unthreatened.

The farm's buildings served as a field hospital following the battle. The only surviving structure from 1863 is the barn, which still bears scars from the fighting. Visitors are reminded, however, that the property is now in private hands and may not be visited.

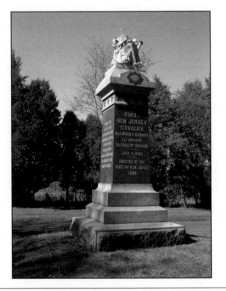

Directed to pull back as the Fifth and Sixth Michigan advanced, the First New Jersey ignored that order. Borrowing ammunition from the nearby Third Pennsylvania Cavalry (see photo J-7), the New Jersey troopers held their position and continued to fight, rather than withdrawing to relative safety.

When Stuart's cavalry made its final charge, the First New Jersey and the Third Pennsylvania Cavalry attacked the flanks of the Confederates. In the fighting that followed, Brigadier General Wade Hampton was nearly killed. Trapped by a fence, he found himself facing the Union troopers from New Jersey. Although Hampton was able to kill several with his pistol and saber, he was struck on the head by one of the saber-wielding New Jersey men. He was also shot in the side. Finally, he was able to leap his horse over the fence that had boxed him in. He did not return to duty until September.

Nearly surrounded at that point, the Southerners were forced to end their charge, and the cavalry battle came to an end.

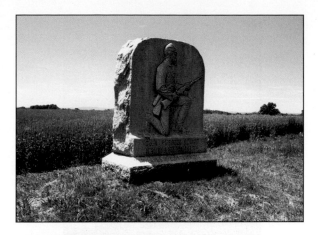

as an intact organization. Each company was detached for duty with another command. This monument is dedicated to Company A, the only one to fight at the East Cavalry Field. Named for William Purnell, postmaster of Baltimore, it served in the First Brigade, Second Division, Fifth Corps under Colonel John B. McIntosh. Its captain was Robert E. Duvall.

The monument depicts a dismounted trooper kneeling with his gun at the ready. It sits in the approximate location where the Purnell Legion posted its colors.

## J-4: Monument to Purnell Legion, Company A
**39°49.588'N, 77°9.877'W**

The Battalion of Cavalry, Purnell Legion, Maryland Volunteers generally did not serve

## J-5: First Michigan Cavalry Monument
**39°49.569'N, 77°9.919'W**

When Stuart's dismounted cavalry was unable to force its way through the Union line, the

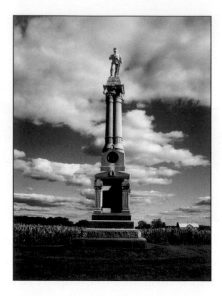

own memorial on the field, the four Michigan regiments chose this one monument only, symbolizing the unity of the brigade.

## J-6: Gregg Cavalry Shaft
**39°49.584'N, 77°9.781'W**

This monument marks the location where the First Michigan Cavalry and Stuart's column clashed. The area surrounding the shaft saw some of the heaviest cavalry fighting on July 3.

Named for Brigadier General David Gregg, who commanded the Union cavalry in the fight

Confederate general ordered a mounted charge, which he felt would be sufficient to breach the line. Upon seeing the charge, General George Armstrong Custer rode to the head of the First Michigan Cavalry and shouted his famous order: "Come on, you Wolverines!"

The First Michigan collided with two brigades of Confederate cavalry commanded by Brigadier Generals Fitzhugh Lee and Wade Hampton. The fighting took place at close range. Many men were trampled by their horses when they were knocked from their saddles. The Third Pennsylvania Cavalry (see photo J-7) and the First New Jersey Cavalry (see photo J-3) moved in to assist. Soon, the Confederate cavalry, under attack from three sides, was forced back to Cress Ridge.

When given the opportunity to each have its

with Stuart, the monument honors all the men who served under Gregg during the battle while also recognizing the bravery of their Southern opponents. This acknowledgment of both sides makes the monument unique among Civil War memorials. Rarely did one side honor the bravery of the other on a monument.

Considered one of the Union's top cavalry commanders, Gregg was a graduate of West Point. His opponent at the East Cavalry Field, J. E. B. Stuart, was in the class ahead of Gregg, and the two knew each other from their days at the military academy. Ordered by his commander, Major General Alfred Pleasonton, to occupy a position between Cemetery Hill and White Run, Gregg protested. His fear was that this position would leave the Union's right flank exposed unnecessarily. Pleasonton refused to rescind the order but allowed Gregg the option of placing a detached brigade at the intersection of Hanover Road and Low Dutch Road, where Gregg wanted to be.

As Gregg gave his orders more thought, he became concerned for the right flank. He moved two brigades into the area, in addition to the brigade already there under Custer's command. His foresight is believed to have been the major reason Stuart was unable to get around the Union's flank and make an attack from the rear.

## J-7: Third Pennsylvania Cavalry Monument
**39°49.637'N, 77°9.754'W**

The Third Pennsylvania Cavalry fought in both the dismounted and mounted portions of the battle, its first encounter coming early in the fighting against troopers from Albert G. Jenkins's brigade under the command of Lieutenant Colonel Vincent A. Witcher near the Rummel Farm buildings.

When Stuart's cavalry made its final charge, Captain William Miller's battalion of the Third Pennsylvania attacked the Confederate left flank at this point. Riding from the cover of the nearby tree line, the Third Pennsylvania struck the rear left of Hampton's column with the First New Jersey Cavalry. In combination with the attack on the Confederate right flank and the front of their

column, Stuart's men were forced back, effectively ending the fighting. Miller was awarded the Medal of Honor for his actions in the charge.

The monument depicts a mounted trooper to commemorate the charge that helped turn back the Confederate cavalry attack.

## J-8: First Maryland Cavalry Monument
**39°49.507'N, 77°9.777'W**

Featuring a horse's head above two crossed sabers to signify its cavalry affiliation, the First Maryland Cavalry's monument sits near the location occupied by the regiment. Assigned to

guard the Union's right flank, the First Maryland Cavalry was not actively engaged in this part of the fighting. Under the command of Lieutenant Colonel James M. Deems, the unit was actually recruited not only in Maryland but also in Pittsburgh, Pennsylvania, and Washington, D.C. To confuse things further, a First Maryland Cavalry also fought on the Confederate side.

The monument in this photo is easily identifiable as a Union memorial by the inscription: "Maryland's Tribute to her Loyal Sons." In this case, "Loyal Sons" refers to those who chose to remain loyal to the Union.

## J-9: First Maine Cavalry Monument
**39°49.075'N, 77°10.154'W**

The unusual design on the monument on page 173 depicts a trooper in full battle gear as he mounts his horse.

Situated on the Union's extreme right, the First Maine was not actively engaged in the fighting until late in the battle, when it was ordered forward. It became more involved following the action at the East Cavalry Field. On July 4, the regiment participated in the pursuit of Lee's army as it moved southward, capturing several stragglers as well as several thousand wounded Confederates over the next few days.

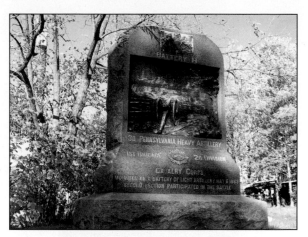

The reverse side of the monument lists the thirty-five major battles in which the regiment participated. Over the course of the war, the First Maine suffered more casualties than any other cavalry troop on either side.

## J-10: Third Pennsylvania Heavy Artillery Monument
**39°49.134'N, 77°10.418'W**

The Third Pennsylvania Heavy Artillery was also known as the 152nd Pennsylvania Volunteers, having been the 152nd regiment organized from the Keystone State. It was actually formed by the consolidation of a marine artillery battery from Fort Delaware and a second artillery battery from Fortress Monroe. Company H spent its entire service in the defense of Baltimore with

only one exception: its time in Gettysburg during the battle.

Company H was said to have fired with extreme accuracy from its position along Hanover Road in helping to eliminate several Confederate batteries. When General J. E. B. Stuart ordered his final cavalry charge, Company H was among the batteries that inflicted heavy damage in repelling the Confederates.

The relief on the monument's front depicts the scene as the artillerists saw it during the battle.

## J-11: Tenth New York Cavalry Monument
**39°49.350'N, 77°11.421'W**

The Tenth New York was the first Union cavalry troop to meet the enemy at Gettysburg,

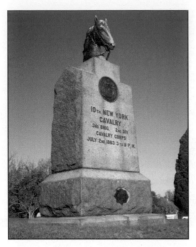

doing so when a squadron fought a skirmish on July 2 at the intersection of Hanover Road and Low Dutch Road. On July 3, the men of the Tenth New York served as skirmishers in the earliest stages of the fighting but were subsequently held in reserve on the right flank and were not actively engaged. Following the battle, the Tenth participated in the pursuit of Lee's army as it retreated.

The Tenth New York was known as "the Porter Guard," after Colonel Peter B. Porter. Its monument features a life-sized horse's head on top.

Back in late December 1861, Trooper John W. Congdon of the Tenth New York Cavalry fell from the top of a railroad car just outside Gettysburg, suffering fatal injuries. He thus had the dubious distinction of being the first Union soldier buried in a Gettysburg cemetery.

## J-12: Sixteenth Pennsylvania Cavalry Monument
**39°49.052'N, 77°11.863'W**

Also known as the 161st Pennsylvania Volunteer Infantry, the Sixteenth Pennsylvania Cavalry was involved in some skirmishing on July 2 near this location. Positioned on the extreme right flank, it was held in reserve during the main battle on July 3.

A trooper stands holding his musket atop a base featuring two crossed cavalry sabers in this memorial to the troopers of the Sixteenth Cavalry, whose ranks were filled by men from twenty of Pennsylvania's sixty-seven counties.

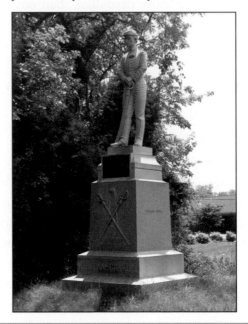

Chapter 11

# GENERAL

## General 1: Flank Markers

Regimental flank markers are small ground-level markers placed to note the extreme ends of particular regiments or batteries. They appear throughout the battlefield. A marker engraved for the Fifth Maine and bearing the letter *R*, for instance (left photo above), represents the right flank of the Fifth Maine Artillery. A similar marker not far away bears the letter *L* to indicate the left flank of the battery. These markings may also appear as *Right* or *Left* or as *RF* or *LF* (Right Flank or Left Flank), as in the photo on the right above.

The value of these markers is that visitors, having located the right and left flanks of a particular regiment, can visualize the line formed by that regiment. This gives them an idea of how far the line stretched, the direction the regiment faced, what the men saw, etc. Such perspective is particularly valuable for those interested in a particular regiment and those researching an ancestor who participated in the battle.

## General 2: Civil War Building Plaques

Plaques such as this adorn numerous buildings throughout the town of Gettysburg. They in-

dicate that the buildings existed at the time of the battle. Many served as hospitals for the wounded of both sides.

## General 3: Corps Markers, Brigade Markers, Battery Tablets

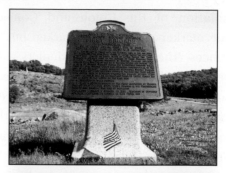

These markers play an important role in helping visitors understand what took place on specific areas of the field, and who was involved. They are invaluable for anyone tracing the path of an ancestor.

All are similar and provide the same basic types of information. The army that the corps belonged to (Army of the Potomac, Army of Northern Virginia, etc.) is listed first, quickly identifying the unit as either Union or

Confederate. The organizational breakdown usually appears next, telling the corps, division, or brigade. The unit's commander is also shown. For lower levels in the organization, such as an artillery battery, the markers go into further detail. A typical corps marker is shown at left.

The next paragraphs on the markers provide battle-specific information, telling when the troops arrived on the field, what they did, where they fought, etc. This is shown by date from the time they arrived.

Brigade markers provide similar information, describing the makeup of the brigades. Typical brigade markers are shown above. An

examination of the Union and Confederate brigade markers shows two marked but subtle differences. The upper photo depicts a Union marker, while the lower is that of a Confederate brigade. Discerning readers will notice that the tablets are shaped slightly differently, the Confederate tablet having a flat top. The concrete mounting pillars are also different; the Union tablet is mounted on a rectangular base, while the Confederate base is a round column. This enables viewers to determine from a distance which side the tablets represents, without having to get close enough to read the inscriptions.

Finally, depending on the type of marker, the number of men from the unit who were killed, wounded, captured, or missing may be listed. In the case of artillery units, the number of horses killed may also be shown. A typical artillery brigade marker appears below.

These tablets are so numerous that most visitors don't take the time to read them. That is unfortunate. So much information is made available in one place that no study of the battle is complete without referring to them.

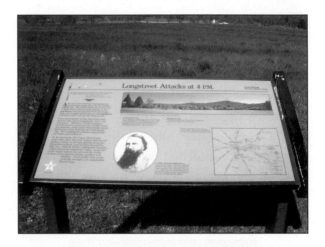

## General 4: Wayside Markers

Hundreds of wayside markers dot the battlefield, providing summaries of what took place nearby during the battle. They are excellent tools for visitors to learn more about the fighting and those who participated. Some have recorded accounts of the events they depict or quotes from some of the participants. The few minutes required to read the information provided on the markers is time well spent and will answer many questions visitors may have.

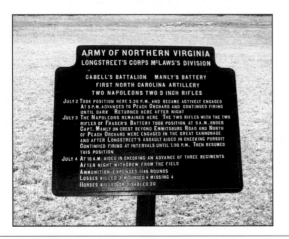

# General 5: Reenactors

Scenes such as these pictured below and on page 180 can be found throughout the battlefield, signifying the presence of reenacting groups. Most reenactors are more than willing to share their knowledge of the regiments they represent, the uniforms they wear, and the weapons they carry. Visitors should not be shy about asking them questions. They reenact because they want to present a living history lesson to those who observe.

Most groups perform demonstrations throughout the day, the type depending on their regiments. Artillery units, for example, provide demonstrations on the loading and firing

of artillery pieces. Other groups may perform medical procedures, marching and arms demonstrations, or even cooking with period utensils. If you are really lucky, you may encounter a Civil War–era band and be treated to a concert of 1860s music using instruments from the time.

While individuals or small groups of reenactors can be found anywhere, the best places to see encampments are in front of the National Wax Museum on Steinwehr Avenue, the Spangler's Spring area (see photo D-5), the area around the General James Longstreet Monument (see photos E-10) on West Confederate Avenue, and the area adjacent to the Pennsylvania State Memorial (see photos G-2).

## General 6: Hospitals

Most buildings of any size, whether homes, churches, offices, or barns, were pressed into service after the battle to treat the more than twenty-two thousand wounded soldiers. Surgeons from both armies worked side by side to provide relief without regard for the colors of the uniforms worn by the injured. As the conditions of the wounded improved, they were moved to corps hospitals or Camp Letterman (see photo B-16).

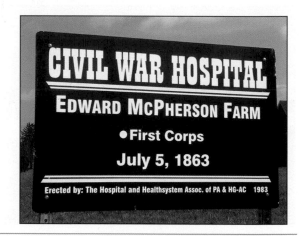

Buildings that served as hospitals during and after the battle are identified by signs like those shown below.

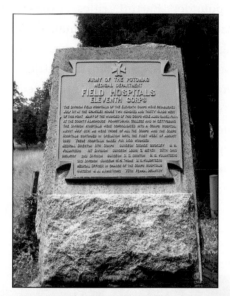

# General 7: Headquarters Markers

Upturned cannon barrels can be seen at numerous locations around the battlefield. These indicate the locations of the headquarters of the various corps commanders and those of the two army commanders, General George Meade for the Union and General Robert E. Lee for the Confederacy. The Union and Confederate markers appear much the same, although the Union cannon barrels are generally taller.

In addition to Meade's headquarters, nine Union headquarters are marked for Abner Doubleday, John Newton, Winfield Scott Hancock, Daniel Sickles, George Sykes, John Sedgwick, Oliver O. Howard, Henry W. Slocum, and Henry J. Hunt. This photo indicates Sedgwick's headquarters.

Three Confederate markers in addition to the one for Robert E. Lee note the approximate locations of the headquarters for James Longstreet, Richard S. Ewell, and Ambrose P. Hill.

## General 8: Cannons

Artillery pieces such as pictured below can be found throughout the battlefield. The Gettysburg National Military Park has about 375 cannons on display. More than just decoration, most are strategically placed to indicate the locations of artillery at the time of the battle.

Four main types of cannons were used at Gettysburg, along with a number of lesser types. The main types were twelve-pounder Napoleon guns, meaning they fired twelve-pound artillery rounds; ten-pounder, twenty-pounder, and thirty-pounder Parrott rifles; twelve-pounder howitzers; and three-inch ordnance rifles. The carriages on which the cannons are mounted are replicas of those used during the battle.

The Union artillery was organized by brigades, each brigade made up of four or five batteries. The Confederate army organized its artillery into battalions. Each battalion was composed of four batteries.

Because of maintenance costs, and to avoid injuries, visitors are asked to refrain from climbing on the cannons.

# INDEX

Thirty-second Infantry, 134–35; Second Andrews Sharpshooters, 135–36

McClellan House, 37

McGilvery, Lt. Col. Freeman, 139

McIntosh, Col. John B., 168–69

McPherson, Edward, 6

McPherson Farm, 6, 11, 61, 101, 181

McPherson's Ridge, 2, 7, 8, 36

Meade, Maj. Gen. George G.: apprised by signalmen, 163; headquarters at Leister House, 119; headquarters marker, 181; holds council of war, 66; monument faced by Lee's, 81; monument to, 117–18; orders Hancock to take command, 52; on Pennsylvania State Memorial, 101; sends Slocum to left flank, 74; sends Warren to Little Round Top, 161; succeeds Hooker, xx, 10

Medal of Honor, 15, 95, 107, 120, 126, 153, 155, 172

Merwin, Lt. Col. Henry C., 133

Michigan troops: First Cavalry, 169–70; Fifth Cavalry, 168–69; Sixth Cavalry, 168–69; First Infantry, 137; Twenty-fourth Infantry, 8, 74

Mickler, James, 4

Military Order of the Loyal Legion (MOLLUS), 104

Miller, Capt. William, 171

Minnesota troops, 142; First Heavy Artillery, 120; First Infantry, 99

Mississippi State Memorial, 86

Mississippi troops: Second Infantry, 12; Eleventh Infantry, 78, 115; Twenty-first Infantry, 144; Forty-second Infantry, 12

Monument Avenue (Richmond), 81

Moore, Maj. John W., 152

Mount Mariah Cemetery, 104

Mount Rushmore, 79

Mudge, Lt. Col. Charles, 65

Mulholland, Maj. St. Clair, 136–37

Munsell, Sgt. Harvey May, 153

National cemetery. See Gettysburg National Cemetery

National Wax Museum, 180

Natural Fortification. See Curious Rocks

New Hampshire troops: Fifth Infantry, 129

New Jersey troops: First Cavalry, 168–71; Sixth Infantry, 148; Eighth Infantry, 130

New York Auxiliary Monument, 141–42

New York Battlefield Monuments Commission, 48, 127, 142

New York City, 111

New York State Memorial, 30, 48

New York troops, 107; Fourth Battery Light Artillery, 149, 151–52; Fourteenth Independent Battery, 134; Fifth Cavalry, 94; Sixth Cavalry, 4; Ninth Cavalry, 4; Tenth Cavalry (Porter Guard), 173–74; Fifteenth and Fiftieth Engineers, 101–2; Twelfth Infantry, 156, 158; Thirty-ninth Infantry, 104; Forty-second Infantry, 105; Forty-fourth Infantry, 156, 158–59; Sixtieth Infantry, 72; Sixty-third Infantry, 133–34; Sixty-ninth Infantry, 133–34; Seventieth Infantry, 126; Seventy-first Infantry, 126; Seventy-second Infantry, 126; Seventy-third Infantry, 126; Seventy-fourth Infantry, 126; Seventy-eighth Infantry, 63, 71–72; Eighty-third Infantry, 16–17; Eighty-eighth Infantry, 133–34, 140; Ninety-fifth Infantry, 12; 102nd Infantry, 63, 71–72; 111th Infantry, 104, 115–16; 124th Infantry, 150; 125th Infantry, 104; 126th Infantry, 104; 137th Infantry, 72; 140th Infantry, 159–60; 146th Infantry, 161; 149th Infantry, 72; 154th Infantry, 28–29; Ninth National Guard, 16–17; Fourteenth Brooklyn Regiment, 12

Newton, Maj. Gen. John, 10, 181

North Carolina State Memorial, 79

North Carolina troops, 15–16, 54, 72; First Infantry, 66; Twenty-third Infantry, 15; Fifty-fifth Infantry, 12

Oak Hill, 15, 20

Oak Ridge, 17, 36

O'Brien, Sgt. William, 78–79

Ohio Troops: Fourth Infantry, 56–57

Old Brigade. See Vermont troops: First Brigade

Old Soldiers' Home, 104

Orange Blossom Regiment. See New York troops: 124th Infantry

O'Rorke, Col. Patrick, 92, 159–60

Orphanage for Children of Deceased Union Soldiers, 30

Paine, Lewis. See Powell, Lewis

Pardee Field, 69

Pardee, Lt. Col. Ario, 69

Pea Ridge, 92

Peace Light. See Eternal Light Peace Memorial

Peach Orchard, 67, 83, 86, 125–26, 142, 161

Pegram, Maj. William R. J., 4

Penelope, 33–34

Pennsylvania College, 27

Pennsylvania Hall, 27

Pennsylvania Monument Commission, 129, 155

Pennsylvania State Memorial, 100–101, 140, 180

Pennsylvania Supreme Court, 109

Pennsylvania troops: First Cavalry (Forty-fourth Infantry, Fifteenth Reserves), 97, 105–6; Third Cavalry, 174; Sixteenth Cavalry, 4; Eighteenth Cavalry, 94; Eleventh Infantry, 1, 17–18; Twenty-eighth Infantry, 71; Twenty-ninth Infantry, 69–70; Thirtieth Infantry (First Reserves), 147; Fortieth Infantry (Eleventh Reserves), 127; Forty-second Infantry (Thirteenth Reserves), 128–29; Sixty-ninth Infantry, 107, 112; Seventy-first Infantry, 106, 111–12; Seventy-second Infantry, 106, 108–9, 112; Eighty-third Infantry, 155–56; Eighty-eighth Infantry, 14–15; Ninetieth Infantry, 13; Ninety-first Infantry, 160–61; Ninety-sixth Infantry, 137–38; Ninety-ninth Infantry, 152–53; 106th Infantry, 112 ; 110th Infantry, 132; 115th Infantry, 130; 116th Infantry, 133, 136–37; 118th Infantry, 137; 140th Infantry, 10–11, 138; 143rd Infantry, 10–11; 147th Infantry, 69; 149th Infantry, 129; 150th Infantry, 8, 10, 129; 152nd Infantry (Third Heavy Artillery), 173; 153rd Infantry, 20; 155th Infantry, 164; Independent Light Artillery, 125–26; Philadelphia Brigade, 106–12; Philadelphia Fire Zouaves, 109

Pettigrew, Brig. Gen. James J., 6, 77, 113, 117, 121

Pfiffer, Sgt. Samuel, 11

*Philadelphia Inquirer*, 29

Philadelphia, Pa., 40, 47, 111

Pickett, Maj. Gen. George, 77, 82, 103, 110

Pickett's Charge: action at the Angle, 112; Armistead leads troops over stone wall, 50; Armistead mortally wounded, 110; artillery bombardment precedes, 106, 110–11, 119; Cemetery Ridge as focal point, 52; commanded by Longstreet, 84; Confederates mass for, 78; copse of trees directional guide for, 107–8; Delaware